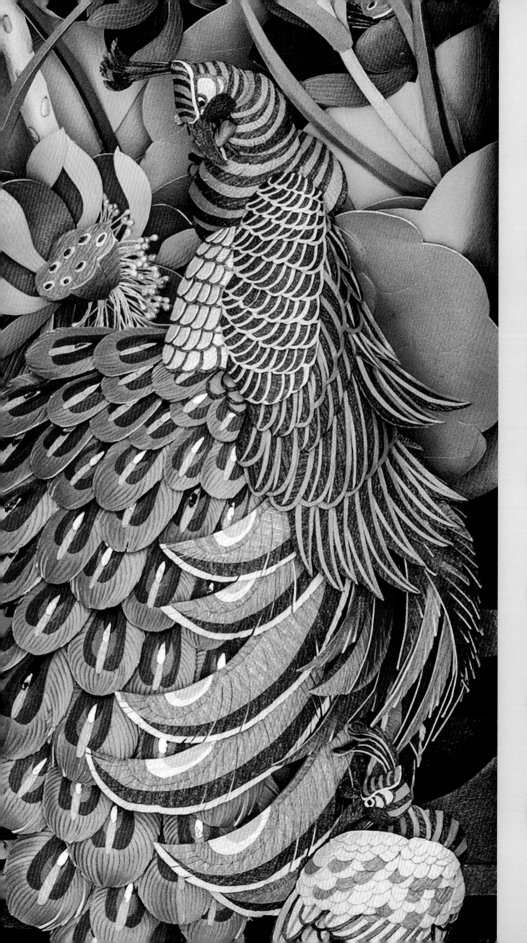

加減藝境

雷安平紙陶雕展專輯

The Art of Addition and Subtraction-
LEI, An-Ping's Paper and Ceramic Carving

局長序

　　設籍臺中市的大墩工藝師雷安平民國61年於臺南出生，父親為退役軍事文官，擅長書法及繪畫。雷安平自幼耳濡目染，對繪畫及手工藝抱持著無比的熱愛。求學時期因緣際會開始紙陶雕的創作，因個性敏銳細膩，經常被選派參與各類平面設計比賽。民國80年自私立大明中學美工科平面組第一名畢業，投入平面設計產業後自研紙浮雕創作技術，並師事李崑源老師學習陶雕技法，無論是立體的表現或平面的處理都各有特色，在傳統工藝或創新設計方面皆屢獲佳績。

　　憑藉著創作的熱情與精湛的雕刻技藝，雷安平在民國102年獲選臺中市第八屆大墩工藝師，103年於葫蘆墩文化中心編織文物館展出第4屆臺中市美術家接力展「刻意情懷－雷安平陶雕創作展」。至今三十餘載的創作生涯，累積了堅強的實力，雷安平的紙陶雕作品不僅獲獎無數，更經常在全臺各地美術文化場館展出。本次在臺中市大墩文化中心舉辦「加減藝境－雷安平紙陶雕創作」，希望將最好的作品呈現給中部的觀眾。

　　對雷安平來說，紙雕是唯美的創作，而茶壺雕刻除了追求美感表現之外，還兼具實用性質，將作品和生活的結合，展現傳統工藝優雅的一面。雷安平的作品色調古雅，造型簡潔、浮雕質感細緻寫實，層次豐富靈活多變，將傳統雕刻與美感連結並推陳出新。雷安平的陶瓷雕刻，在題材上多以多變的花草、吉祥紋飾為設計主題，表現出獨特的自我風格；在作品空間的安排上，可見到虛實層次的運作，竹葉、松根、圓梅層層交錯，利用明暗對比技巧雕琢出多層次的視覺效果。雷安平擅於觀察並捕捉自然景物，加入自身美感，創作出動人的形象，其作品精緻且具有創意，無論在傳統工藝或設計方面都屢獲佳績。

　　臺中市是個人文薈萃且文化底蘊深厚的大城市，素有文化城之美譽。本次「加減藝境－雷安平紙陶雕創作」，秉持藝術推廣的精神，希望在雷安平老師的帶領下，讓大家一窺紙陶雕工藝的創作及其延伸性，是一場不容錯過的藝術饗宴。

臺中市政府文化局長　**陳佳君**

2

Preface

Taichung-based Dadun Craftsman Master Lei An-Ping (雷安平) was born in Tainan in 1961. His father was a veteran civilian official good at calligraphy and painting. Lei An-Ping was immersed in them as a child and developed an extraordinary love for paintings and handicrafts. During his studies, he started to create sculptures in paper and ceramics by chance. With his sensitivity and attention to details, he was often chosen to participate in various competitions of graphic design. In the 1980s, he graduated first of the class of graphic design from the Department of Arts and Crafts at the Ta Ming High School. He later got into the business of graphic design and developed the techniques of paper reliefs by himself and studied the techniques of ceramic sculptures from master Li Kun-Yuan (李崑源). He shows his special styles with both his works of both two-dimensional and three-dimensional arts, and he has been a decorated artist in traditional craftsmanship and innovative designs.

With his enthusiasm for creation and exquisite sculpting skills, Lei was selected as one of the masters of the 8th Dadun Craftsmen in Taichung City in 2013. In 2014, he participated in the 4th "Artists' Relay Exhibitions" in the Textile Exhibition Hall at the Taichung City Huludun Cultural Center with "Sculpted Minds: Ceramic Sculptures by Lei An-Ping." With his career as an artist of over 30 years, Lei has sharpened his skills as an artist. His works of sculptures in paper and ceramics have won him countless awards and taken him to exhibitions in places all around Taiwan. This time, "The Art of Additions and Subtractions: Paper and Ceramic Sculptures by Lei An-Ping" is hosted at the Dadun Cultural Center in Taichung City, and we hope it shows the best of Lei's works to the art lovers in Central Taiwan.

For Lei, paper sculpting is for pure aesthetics, while teapot sculpture not only pursues artistic expression but also has practicality. The latter combines works with life, showing an elegant aspect of traditional craftsmanship. Lei's works are traditional in color, simple in shape, meticulous and realistic in their textures with reliefs. They're rich in layers and versatile, breathing aesthetics into traditional sculpture with innovations. The ceramic sculpture by Lei mostly take whimsical flowers and plants and auspicious patterns as themes with a unique personal style. In his spatial arrangement one can see the interplay of virtual and real layers, with bamboo leaves, pine roots and plum blossoms stacked together. The sculpting technique of chiaroscuro creates a visual effect of multiple laters. Lei excels in observing and capturing natural scenery. With his own sense of beauty, he created moving images. His works are exquisite and creative, and they have won him a lot of awards in either traditional craftsmanship or design.

Taichung City is a metropolitan that brings together many talents with a profound cultural heritage, dubbed the City of Culture. This time, directed by master Lei, "The Art of Additions and Subtractions: Paper and Ceramic Sculptures by Lei An-Ping" grants everyone a glimpse of the works of paper and ceramic sculpture and their extensibility in the spirit of promoting arts to the public. It is a feast of arts that shouldn't be missed.

Director of the Cultural Affairs Bureau
of Taichung City Government **Chen, Chia-Chun**

自序

　　自幼便對繪畫抱持著無比的熱愛，而在30年前的一次偶然機會中，我與紙陶雕結緣，開始對創作有了興趣，從那時起，我便開始探索紙陶雕的世界。

　　創作的過程中充滿了挑戰、取捨和學習。然而，當每一件作品完成時，那份成就感總能使我對這一切挑戰甘之如飴。逐漸地，我對紙陶雕產生了一種追求和使命感。

　　「紙浮雕」是以剪、黏、堆、疊加法技法創作，觀賞掛畫的形式呈現，而「陶雕」則是在茶器等實體物品上進行實體雕刻，使用減法技法展現作品的浮雕鏤刻效果。我嘗試融合傳統技法和多種元素，如花鳥、瑞獸、經文、人物、魚蟲、瓜果、幾何圖形和吉祥紋飾，賦予作品古雅的色調和細緻寫實的質感，呈現出豐富多變的層次感。這種創作方式展現了技法的難度，同時凸顯了傳統工藝的優雅之處，提升了作品實用和觀賞新藝境。

　　在「紙浮雕」中，紙被視為絕佳的藝術媒材，可以透過搓、擦、撕、剪、燒、扭、染、切、雕、疊和黏等多種技法展現其獨特的風格，無論是立體的表現或平面的處理都各有特色。

　　至於「陶雕」—陶雕茶器除了美的創作，還兼具有實用性質，陶雕是經由陶藝家用臺灣陶土手拉胚製成後，由我依陶身造型，再將陶刻表現於陶胚上，使其能達到至善至美的境界，浮雕、鏤雕層次變化多，亦需注意整副造景結構之美感，其作品雕工相當費時，對眼力損傷甚大，雕刻完成後得經一千多度高溫火爐的淬煉，稍有不慎破裂，一切努力將前功盡棄，所以每一件作品都是經過層層工序精心製作出來的。

　　每種材質都有其獨特的表達方式，紙和陶也不例外。我尊重材質的特性，將內心的構思化為具體的作品，這種視覺溝通方式是我一直追求和努力的方向。

　　我要衷心感謝這次展覽中獲得的眾多協助。特別感謝臺中市政府文化局大墩文化中心的邀請以及陳佳君局長的賜序，還有製壺的李崑明老師、謝志成老師、書法的詹益承老師和金工的許國忠老師，跟協助這次展覽的所有人員，我萬分感謝，最後我要感謝我的家人在創作這條路上的陪伴支持，讓我能專心一志於創作。

雷安平

Artist's Preface

My overwhelming love for painting started during my childhood. Thirty years ago I came across sculptures in paper and ceramics and developed interests in them. Since then, I have begun to explore the world of sculptures in paper and ceramics.

The creative process is full of challenges, trade-offs and learning. However, when each piece is completed, the sense of accomplishment always helps me overcome and enjoy all these challenges. Gradually, I developed a sense of pursuit and mission towards sculptures in paper and ceramics.

"Paper relief sculpting" is created by the techniques of cutting, gluing, stacking and superimposing, and it's presented in the form of hanging paintings as ornaments, while "ceramic sculpting" is carving on tea sets and other physical objects, using the subtractive technique to achieve the effects of reliefs and fretworks. I try to integrate traditional techniques and various elements, such as flowers and birds, auspicious animals, scriptures, characters, fish and insects, melons and fruits, geometric shapes and auspicious patterns, to endow artworks with classical hues and realistically fine textures, presenting rich and varied layers. This way of creation attests to the difficulty of techniques while highlighting the elegance of traditional craftsmanship, and it redefines the artistic value of the works that combines practicality with aesthetics.

In paper reliefs, the paper is regarded as an excellent medium for art, the characteristics of which could be exhibited through various techniques such as rubbing, scratching, tearing, scissoring, burning, twisting, dyeing, cutting, carving, stacking and gluing. Both three-dimensional presentations and two-dimensional treatments are distinctive in their own way.

As for ceramic sculpting, sculpted ceramic tea utensils possess not only artistic but also practical values. The ceramic sculptures were based on greenware built by Taiwanese pottery artists, which I further sculpted according to their shapes to reach their utmost artistic beauty and perfection. There are many possibilities in the layers of reliefs and fretworks, and it is also necessary to pay attention to the wholistic aesthetics of the entire structure. Carving the pieces requires a lot of time and damages one's eyesight. After the carving is finished, the piece needs to undergo the test of high temperature in the kiln up to 1,000 degrees celsius. Any careless mistake would lead to cracks that undermine all previous efforts. Therefore, each piece was carefully crafted through many processes.

Every material has its own unique way for artistic expressions, and paper and ceramics are no exception. I respect the characteristics of materials and turn my inner concepts into concrete works. This way of visual communication is the direction I have been pursuing and striving for.

I'd like to express my sincere gratitude for the assistance I've received to pull off this exhibition. Special thanks for the invitation of the Taichung City Dadun Cultural Center under the Cultural Affairs Bureau of Taichung City Government and the foreword by the Director of the Cultural Affairs Bureau Chen Jiajun (陳佳君). I am extremely grateful to pottery masters Li Kun-Ming (李崑明) and Hsieh Chih-Cheng (謝志成), calligraphy master Zhan Yi-Cheng (詹益承), metalworking master Xu Guo-Zhong (許國忠), and everyone who helped with this exhibition. Finally, I would like to thank my family for their company and support on the path of art, so that I can dedicate myself to creating it.

LEI, An-Ping

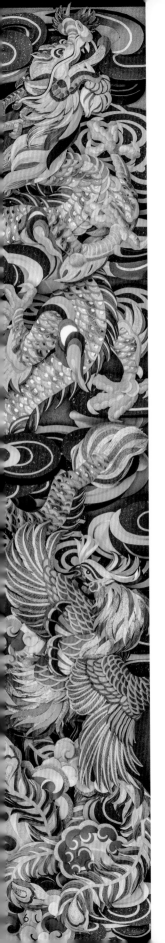

目次

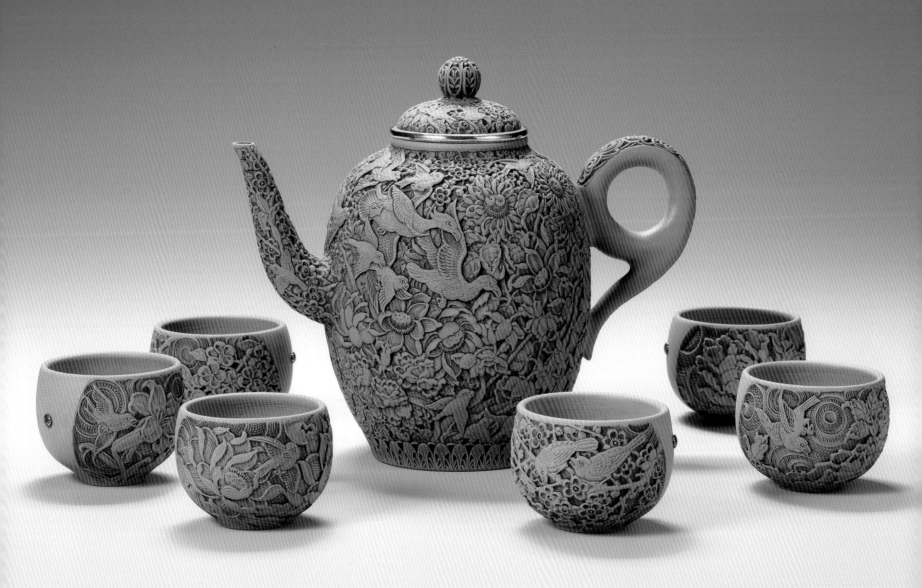

百花爭豔 In Full Bloom

壺 24×13×19cm・杯 7×7×5cm×6件　2020　黃泥
2021臺灣工藝競賽得獎作品

此組作品以現代表現手法對傳統造型推陳出新，以豐富的花、鳥、吉祥紋飾呈現在茶器上，整幅造景質感細膩寫實典雅，層次豐富多變，讓品茗也能追求茶道新意境。

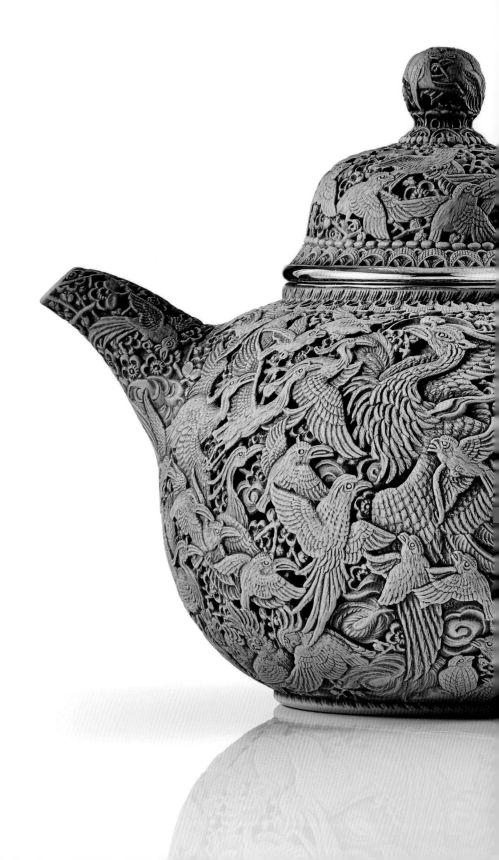

百鳥朝鳳
Hundreds of Birds Paying Respect to the Phoenix

壺 25×15×18cm．杯 7.5×7.5×7cm×2件　2022
黃泥、金
2023臺中當代藝術家邀請展作品

鳳凰浴火救百鳥，百鳥獻羽獲重生。
森林大旱鳥兒沒食物，鳳凰把自己收集的果實分給
大家共渡難關。旱災過後，鳥兒都從身上選一根最
漂亮的羽毛，製成光彩耀眼百鳥衣獻給鳳凰，並一
致推舉鳳凰為鳥王。以後每逢鳳凰生日，四面八方
鳥兒都會來祝賀，有德高望重者眾望所歸之意。

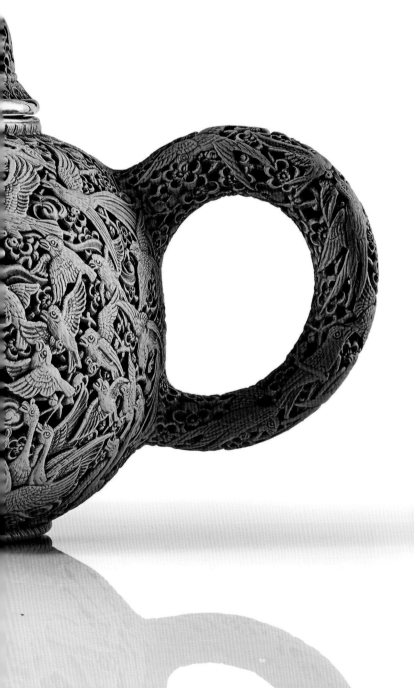

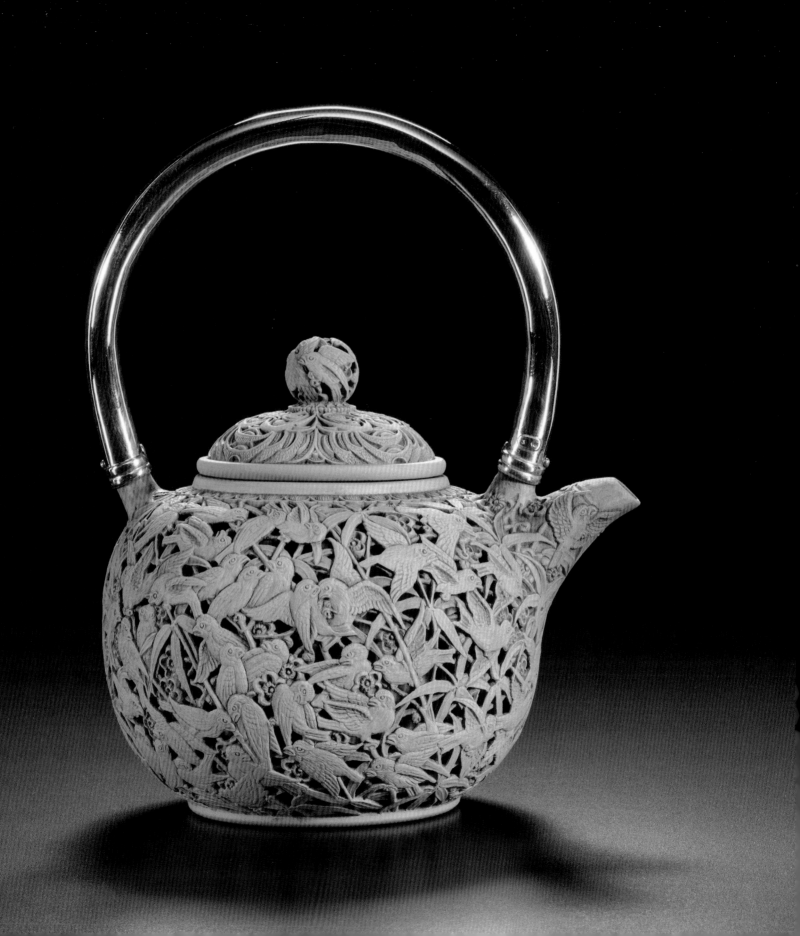

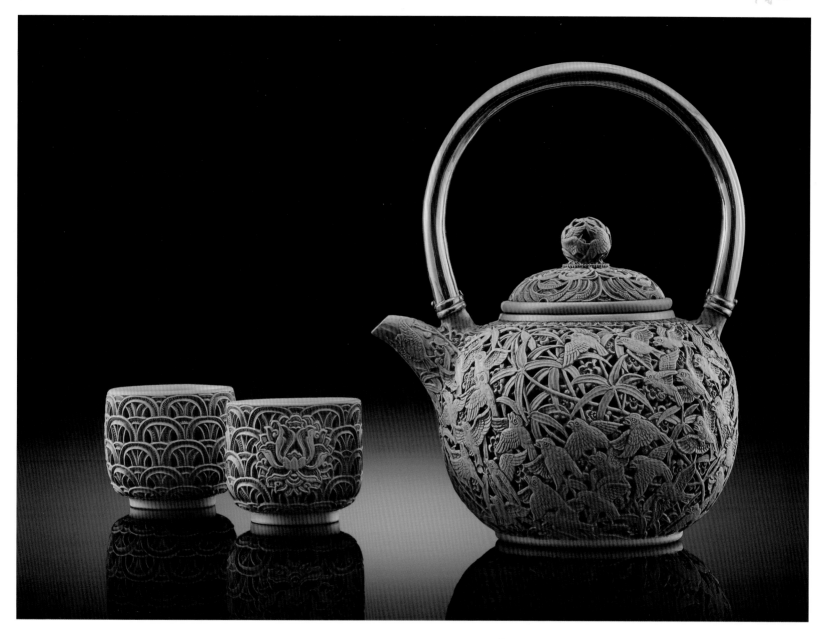

百爵圖 A Hundred Sparrows

壺 15.5×13.5×20.5cm
杯 7.5×7.5×6.5cm×2件
2021 黃泥、金（17.65錢）、雙層鏤雕提梁壺

「百」是眾多吉祥賜福圓滿之意，麻雀象徵「爵」，「爵」，「雀」寓意相通，為加官進爵、自由、勤奮之意。

壺把提梁以金工裝點，壺扭、內牆以多層次雀鳥盤旋，壺蓋配上多變圖騰紋飾，壺身的梅樹與竹叢，眾多雀鳥爭枝振翅，上下踴躍，或就地啄食、或相依相親、或憩息，千姿百態，有著情趣生自然之境。

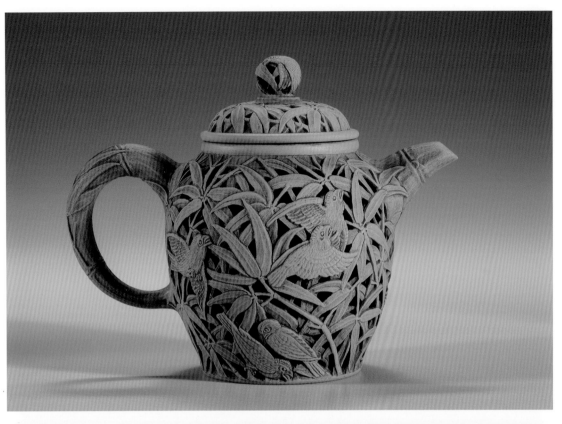

迎風 Windward

壺 15.5×9×12cm 2021
黃泥、雙層鏤雕壺

竹子優雅，寓意節節高昇，每節
之間恰似信念之堅，竹子傲然獨
立的生命力，令人起敬。

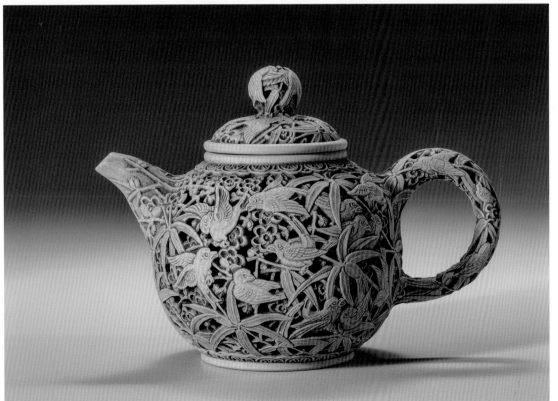

梅竹迎春
Springtime for Plum Blossoms and
Bamboo

壺 16.5×10×11.5cm 2022
黃泥、雙層鏤雕壺

梅花爭豔競放，雀鳥無限靈動活
力，竹子展現生命氣節，表示
萬物復甦，大地回春花木欣欣向
榮，迎接春的到來。

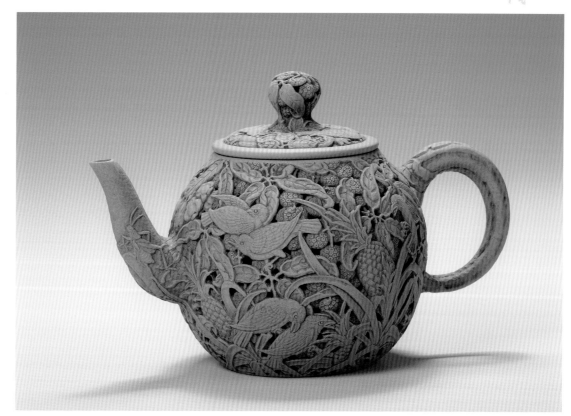

結實纍纍 Fruitfulness

———————————

19×10.5×13cm
黃泥、雙層鏤雕壺

擷取臺灣四季水果形貌,搭配飛
鳥蟲鳴點綴,呈現熱鬧有趣豐收
四季果實的歡樂氣氛。

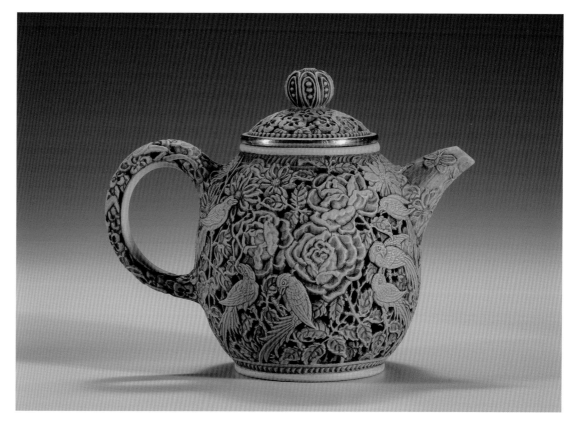

花團錦簇 Blossoming Prosperity

———————————

15.5×9×12.5cm 2022
黃泥、銅、雙層鏤雕壺

春暖花開好時節,各種繽紛綻放
的花朵和鳥語呢喃形成一道美麗
風景,讓人賞心悅目,美不勝
收,洋溢出一種浪漫的春日幸
福。

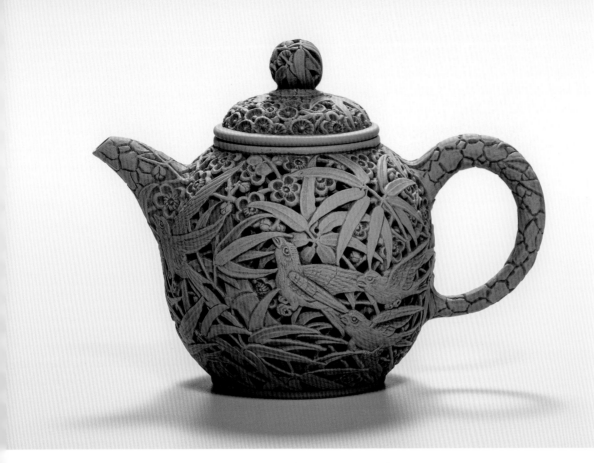

歲寒三友 Three Friends of Winter

15×8.5×11.5cm
黃泥、雙層鏤雕壺

松、竹、梅以歲寒三友相稱，將花木的自然特徵與人的美好品德結合起來，刻畫出生命品格。

大發紅利 Vast Riches

15.5×9×11cm 2021
黃泥、雙層鏤雕壺

以傳統吉祥元素為特點，刻以蟈蟈、荔枝、八歌鳥，取其諧音，蟈蟈高高在上寓意官居一品，荔枝、紅利興旺之意，八哥鳥、諧音「發」似有財源滾滾而來之意。

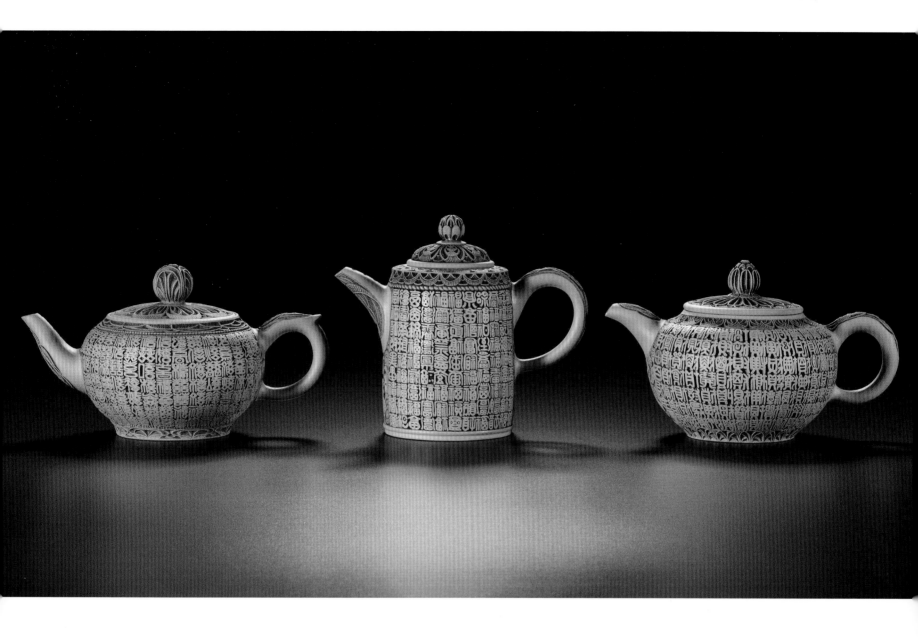

百壽百喜 Longevity and Happiness
16.5×10×9.5cm 2021 黃泥

百祿百福 Fortune and Blessings
14.5×7.5×12.5cm 2017 黃泥

百財進利 Riches and Wealth
16.5×11×10cm 2021 黃泥

「福祿壽喜財」分別代表幸福、升官、長壽、喜慶、發財五個方面的人 生嚮往追求。

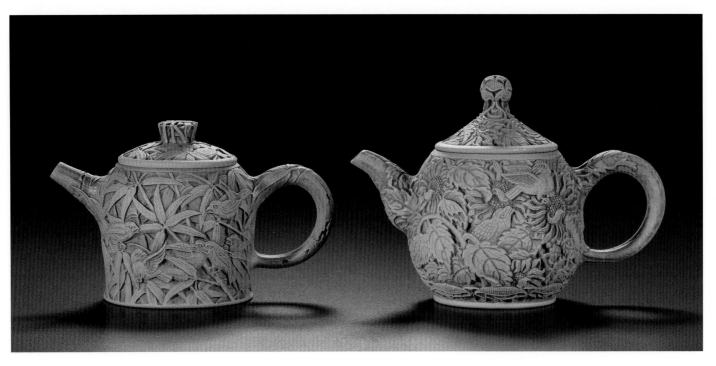

鳥鳴林間繞 Twitters in the Woods
13×7×8cm 2017 黃泥

日日向朝陽 Daily Audience with the Sun
14×8×10cm 2017 黃泥

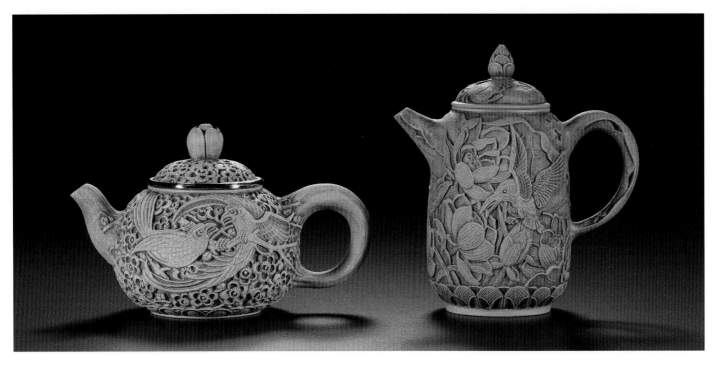

百梅珍喜 Treasuring Plums with Happiness
15×9×9cm 2015 黃泥、銀
2017臺南美展得獎作品

翠羽幽香 Kingfisher and Floral Scents
11.5×7×12.5cm 2011 黃泥

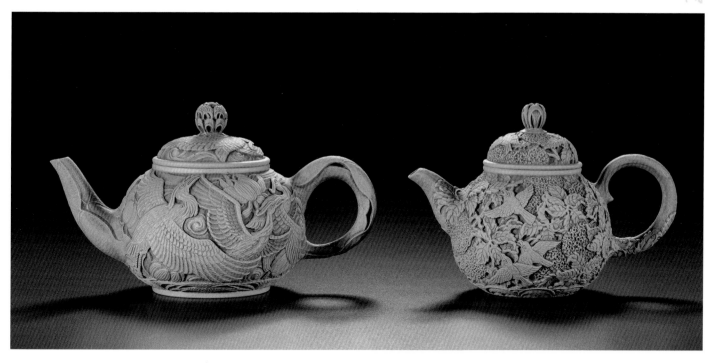

一路連科 Advancement in Imperial Exams
16.5×9×9.5cm 2015 黃泥

花團錦簇 Blossoming Prosperity
13.5×8×9.5cm 2017 黃泥

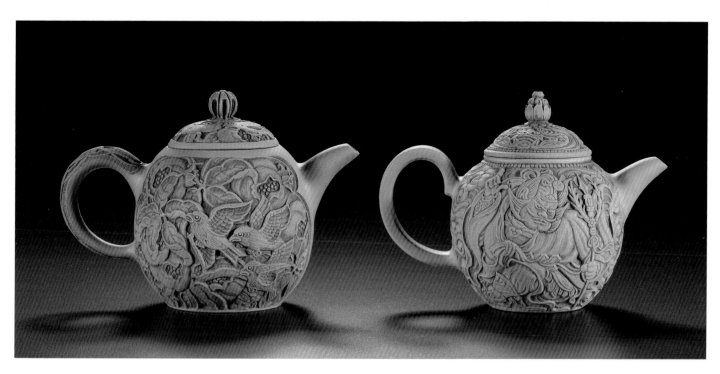

福開百子 Hundreds of Seeds
15×9×10.5cm 2015 黃泥

祈福致慶 Prayer and Celebrations
14.5×9×11cm 2021 黃泥

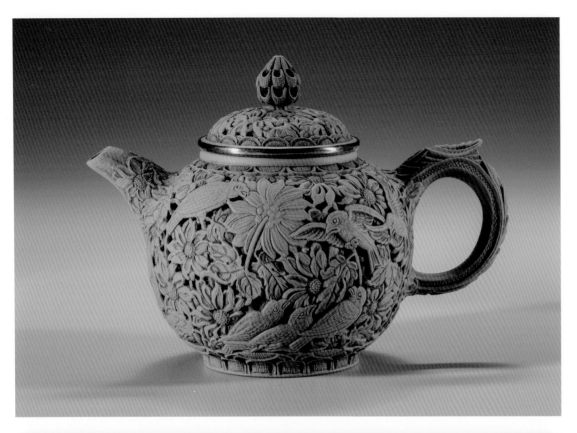

芳香滿園 A Fragrant Garden

15×10×11.5cm 2021
黃泥、銅、雙層鏤雕壺

滿園的金黃秋菊散發淡淡的芳
香，花香四溢，沁人心脾。

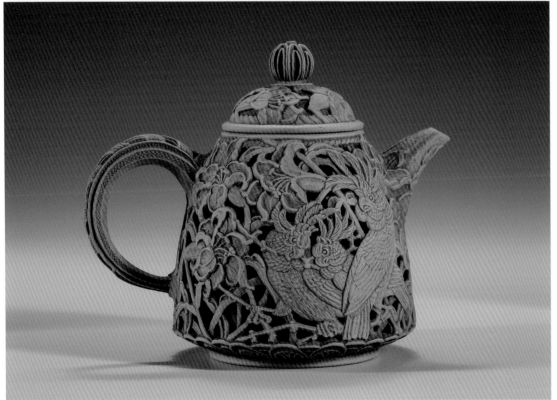

百事如意 The Best of Luck

15×10×12cm 2021
黃泥、雙層鏤雕壺

百合花的花語是順利、祝福、高
貴，意寓心想事成、吉祥如意。

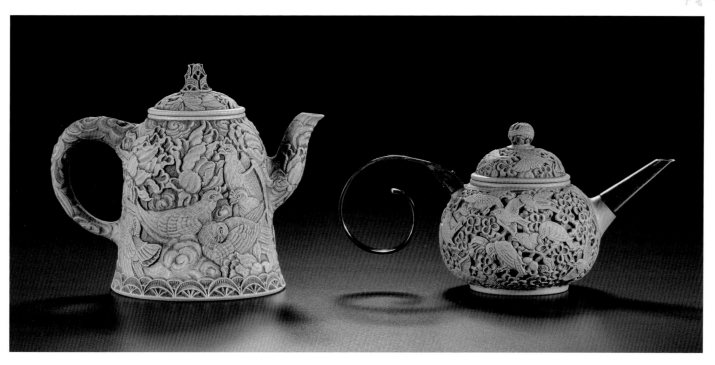

和平富貴 Peace and Prosperity
14.5×9×12cm 2016 黃泥

滿圍春色 A GardenFull of Spring
19×8.5×9cm 2017 黃泥、銀

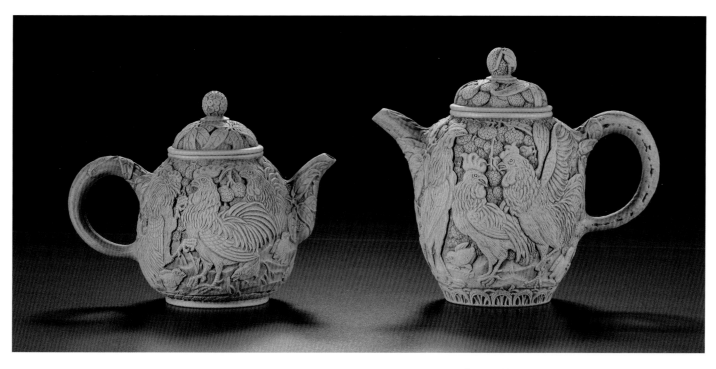

大吉大利 Orange for the Best Luck
13×8×10.5cm 2017 黃泥

吉利長紅 Long Lasting Luck
14×8×12.5cm 2020 黃泥

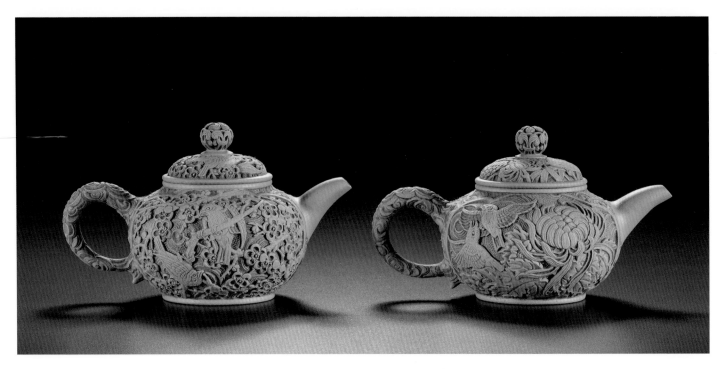

君子壺（梅、蘭） The Prince's Pot (Plum Flowers and Orchids)
14×9×8.5cm 2017 黃泥

君子壺（竹、菊） The Prince's Pot (Bamboo and Chrysanthemum)
14×9×8.5cm 2017 黃泥

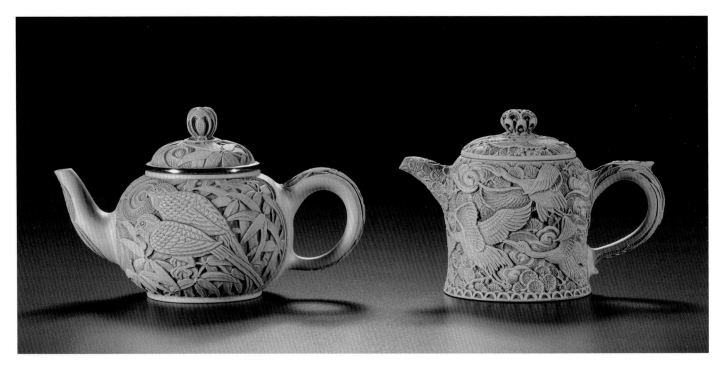

儷影依依 The Loving Pair
16×9×9.5cm 2015 黃泥、銀
2017臺南美展得獎作品

松鶴延年 Live Long as Cranes and Pine Trees
14×7.5×9.5cm 2017 黃泥

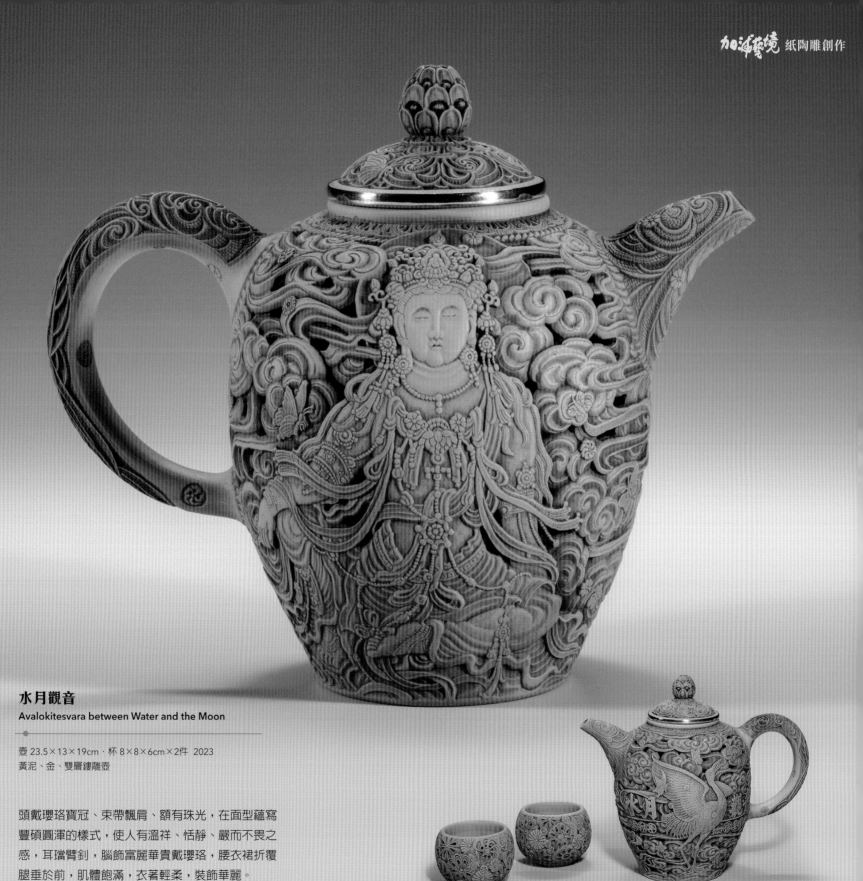

水月觀音

Avalokitesvara between Water and the Moon

壺 23.5×13×19cm・杯 8×8×6cm×2件 2023
黃泥、金、雙層鏤雕壺

頭戴瓔珞寶冠、束帶飄肩、額有珠光，在面型蘊寫
豐碩圓渾的樣式，使人有溫祥、恬靜、嚴而不畏之
感，耳璫臂釧，腦飾富麗華貴戴瓔珞，腰衣裙折覆
腿垂於前，肌體飽滿，衣著輕柔，裝飾華麗。

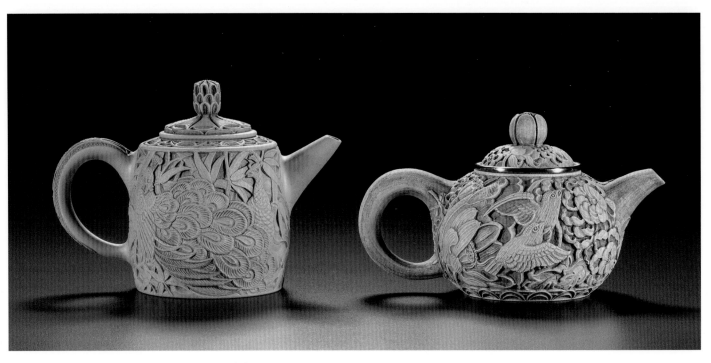

富貴長春 Evergreen Prosperity
14×7.5×10cm 2015 黃泥

四季風華 The Glamours of Seasons
14.5×9×8.5cm 2015 黃泥、銀
2017臺南美展得獎作品

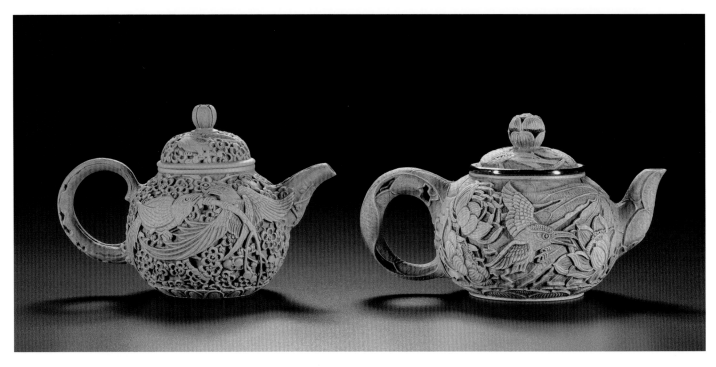

百梅迎喜 Plum Blossoms for Happiness
14×8×9cm 2017 黃泥

荷塘清趣 Upon the Lotus Pond
15×9×9cm 2015 黃泥、銀
2017臺南美展得獎作品

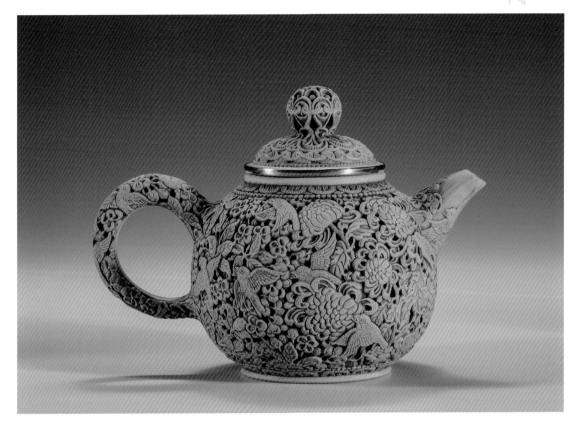

美意延年
Live Long with Beauty

17×11×12cm　2023
黃泥、銅、雙層鏤雕壺

菊花有延年延壽，祝福吉祥長
壽、無憂之美意。

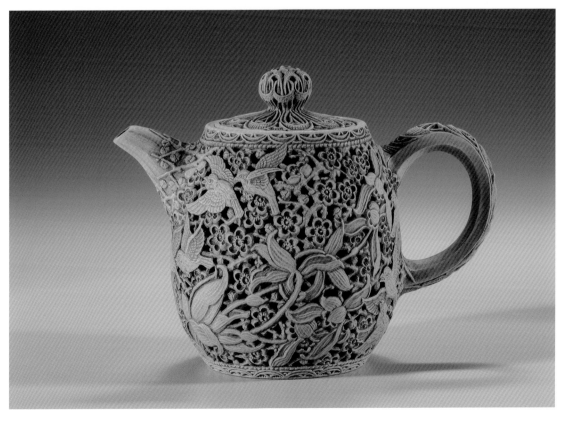

四友君子 The Four Noble Ones
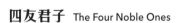

15.5×9.5×12cm　2022
黃泥、雙層鏤雕壺

花中四君子－將花木的自然特徵
與人的美好品德結合起來，賦予
其高潔品格。

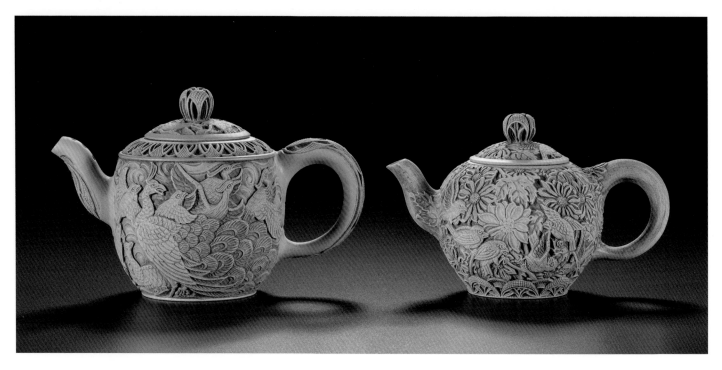

靈禽獻瑞 The Offering from Birds
16×9×11cm 2015 黃泥

集瑞 All the Best of Propserity
15×9×9.5cm 2016 黃泥

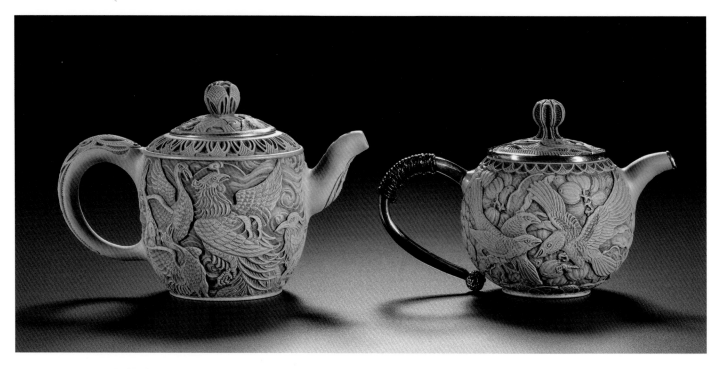

靈禽獻瑞 The Offering from Birds
16.5×9×10.5cm 2015 黃泥、鋁

碩果 Bearing Fruits
15.5×9×10cm 2010 黃泥、銀

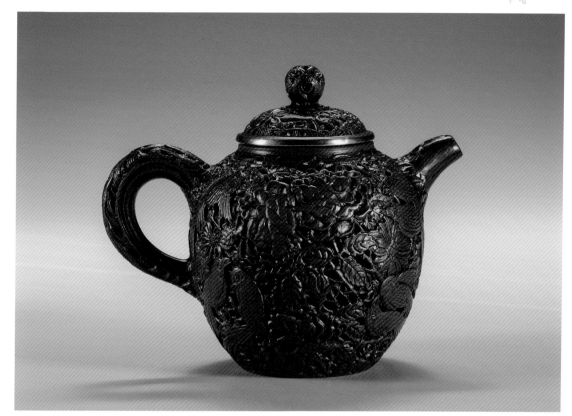

群芳獻瑞
The Offering from Flowers

14×9×11.5cm 2019
紅泥、銅、生漆、雙層鏤雕壺

繁花盛開,萬紫千紅爛漫,有
著萬物無限生機欣欣向榮,呈
祥獻瑞之意。

竹韻生風
The Wind in Bamboo Forests

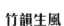

14×9×9.5cm 2019
黃泥、銅、生漆、雙層鏤雕壺

竹韻指風吹竹子的聲音,與雀
鳥形成一動一靜清新秀雅的聲
音畫面。

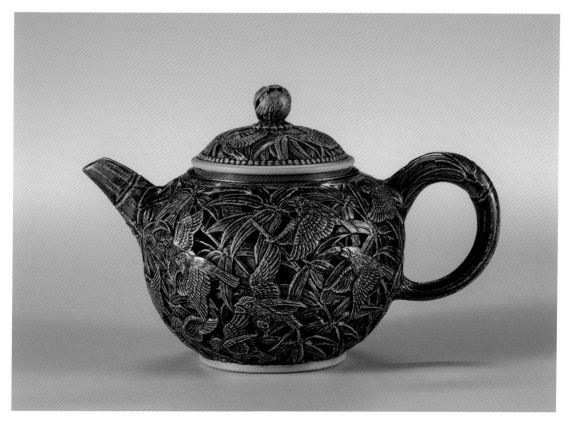

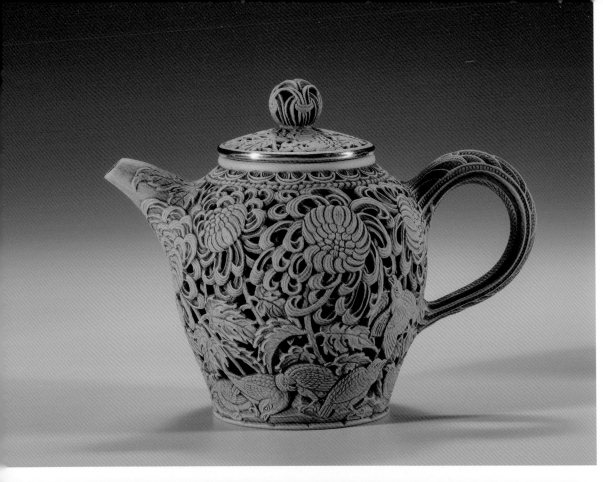

安居樂業

Live in Peace and Work with Joy

16×9.5×12.5cm 2022
黃泥、銅、雙層鏤雕壺

雕刻鵪鶉鳥與菊花，意寓「安居樂業」有寄託人們希望生活安定美滿、工作順遂之意。

豐收時節

Harvest Season

15.5×9×11cm 2023
黃泥、銅、雙層鏤雕壺

飽滿的果實掛滿枝頭鮮艷欲滴，吸引鳥類前往穿梭覓食，給人富饒豐收之印象。

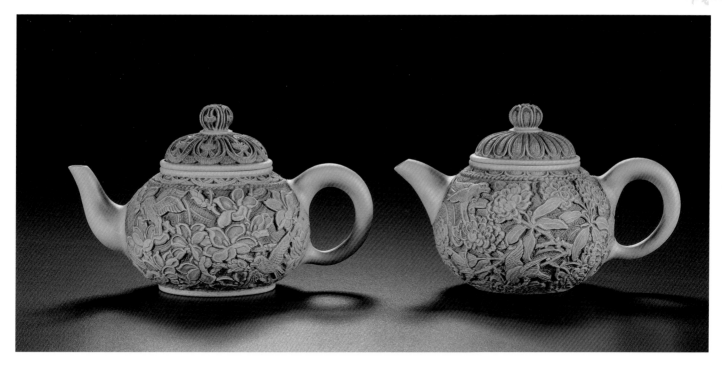

繁花盛綻 In Full Blossom
15×9×9cm 2023 黃泥

春禧 The Joy of Spring
14×9×9cm 2023 黃泥

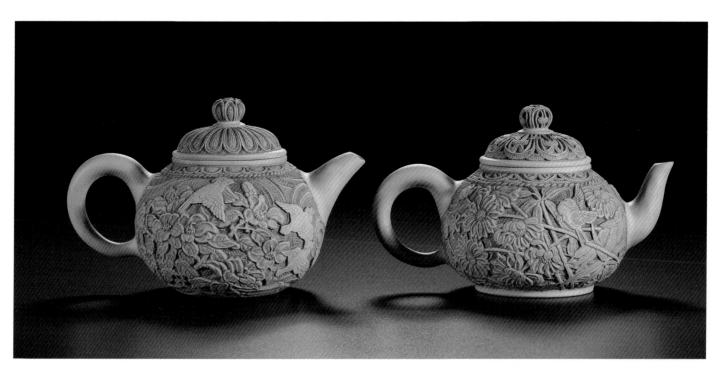

富貴喜迎 Ushering in Happiness
14×9×9cm 2023 黃泥

綻放如錦 Chrysanthemum in Full Blossom
14.5×9×9cm 2023 黃泥

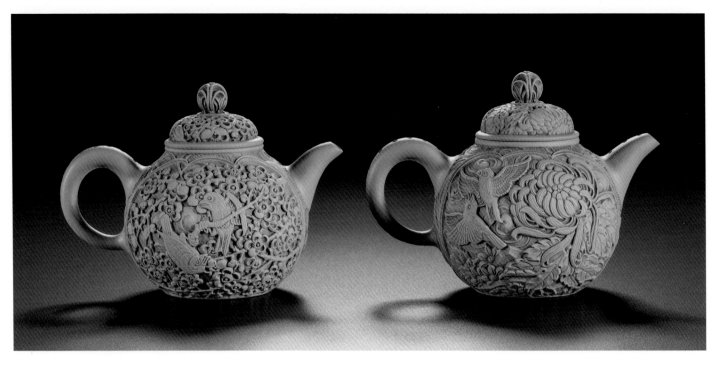

梅蘭 Plum Blossoms and Orchid
14×9×10.5cm 2020 黃泥
2018玉山美術獎得獎作品

竹菊 Bamboo and Chrysanthemum
14.5×9.5×11cm 2020 黃泥
2018玉山美術獎得獎作品

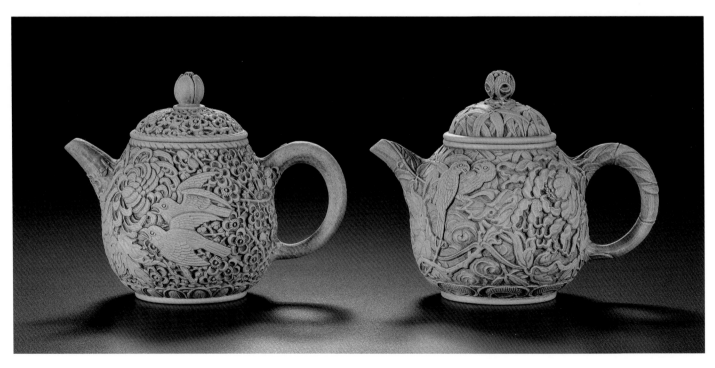

四季 Four Seasons
13×8×10cm 2019 黃泥

富貴良緣 Fortune for a Harmonious Union
13.5×8×10.5cm 2019 黃泥

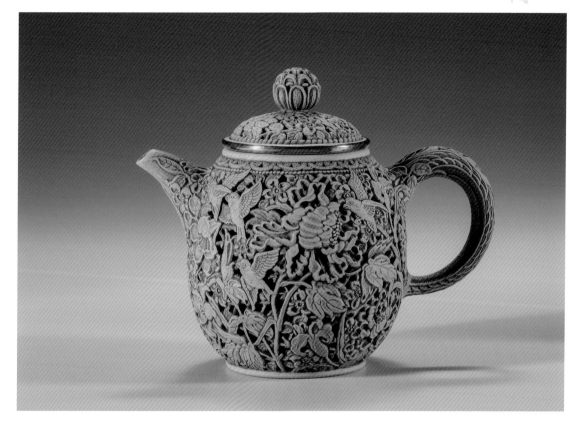

群芳爭豔
Beauty Pageant among Flowers

12.5×9.5×12.5cm 2022
黃泥、銅、雙層鏤雕壺

春回大地繁花似錦，百花綻放
爭奇鬥豔，景色美不勝收。

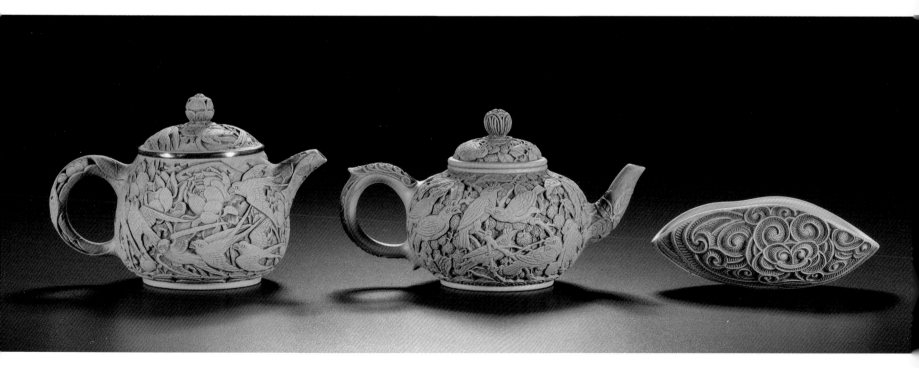

荷香燕語 Swallows Chirp with the Fragrance of the Lotus
13.5×8.5×9cm 2019 黃泥、銅

大發利市 Fruitful Businesses
15×9×8.5cm 2017 黃泥

如意（茶匙） Ruyi (Teaspoon)
11×6.5×4.5cm 2023 黃泥

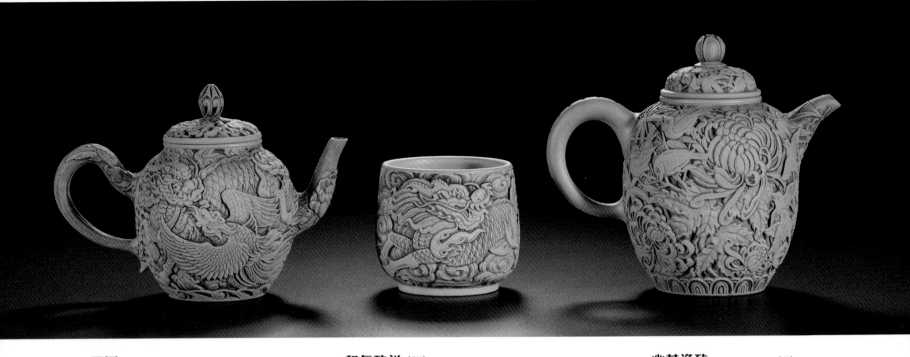

三王圖 The Three Kings
14.5×7.5×10cm 2017 黃泥

和氣致祥（杯） Harmony and Prosperity (Cup)
7×7×6cm 2017 黃泥

幽芳逸致 Fragrance and Elegant
14×8.5×12cm 2020

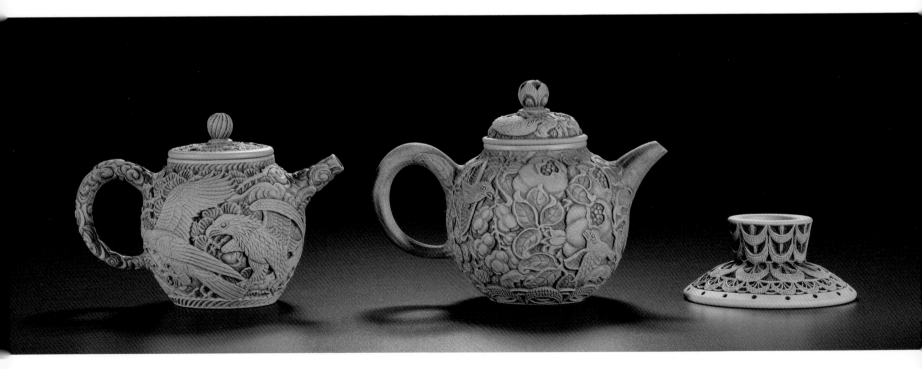

鷹揚萬里 Falcon Crossing a Thousand Miles
12.5×7.5×8.5cm 2017 黃泥

豐碩年年 Fruitfulness All the Years
13.5×8.5×10cm 2015 黃泥

花開（蓋置） Blooming (Lid)
8×8×4cm 2023 黃泥、銅

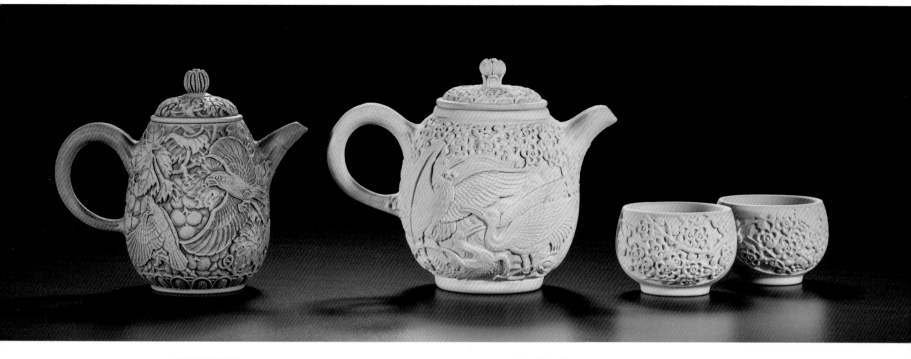

明珠兆豐年 Pearl for the Prosperous Year
13.5×7×12cm 2015 黃泥

福壽康寧 Longevity in Peace
壺 15.5×9.5×12cm · 杯 6.5×6.5×4.5cm 2016 白瓷

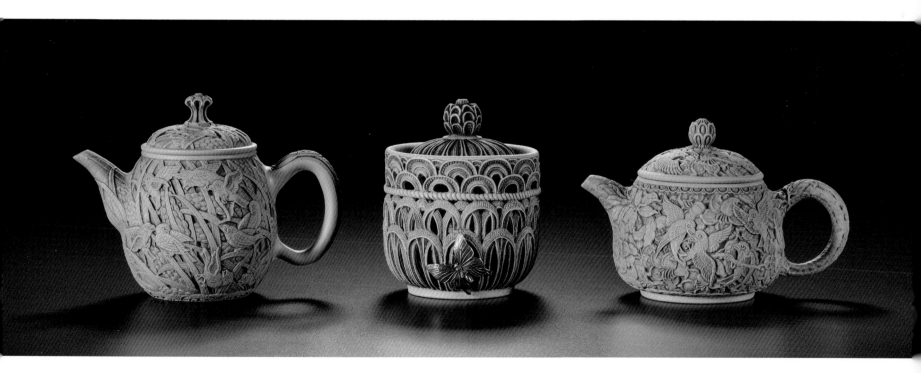

稻香 The Scent of the Rice Fields
13×7.5×9.5cm 2017 黃泥

盛開（鏤雕茶倉） Blooming (Carved Tea Container)
8×8×9.5cm 2021 黃泥、銀、銅

春意盎然 Full of Spring
13×8.5×9cm 2019 黃泥

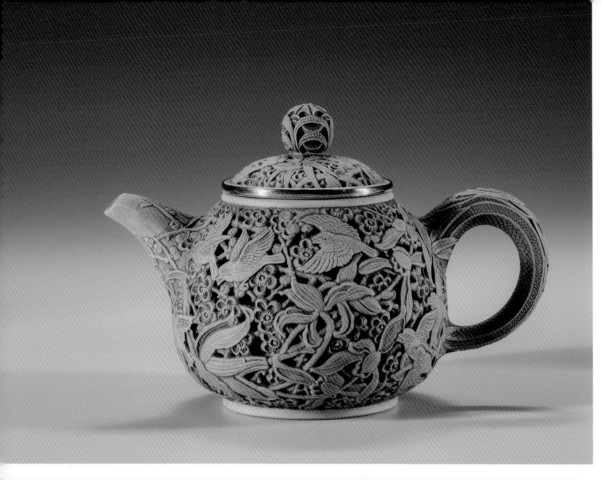

梅蘭竹菊
Plum Blossoms, Orchid, Bamboo, and Chrysanthemum

16×10×11cm 2023
黃泥、銅、雙層鏤雕壺

梅花雪中來，劍蘭幽谷藏，竹
林風吹過，紫菊飄淡香，梅、
蘭、竹、菊以四居子相稱。

豐收
Harvest

16.5×10×12cm 2022
黃泥、雙層鏤雕壺

秋日暖陽煦煦來，數隻燕兒各
俱姿態，果實飽滿沉甸甸的，
一派祥和呈現豐收好時節。

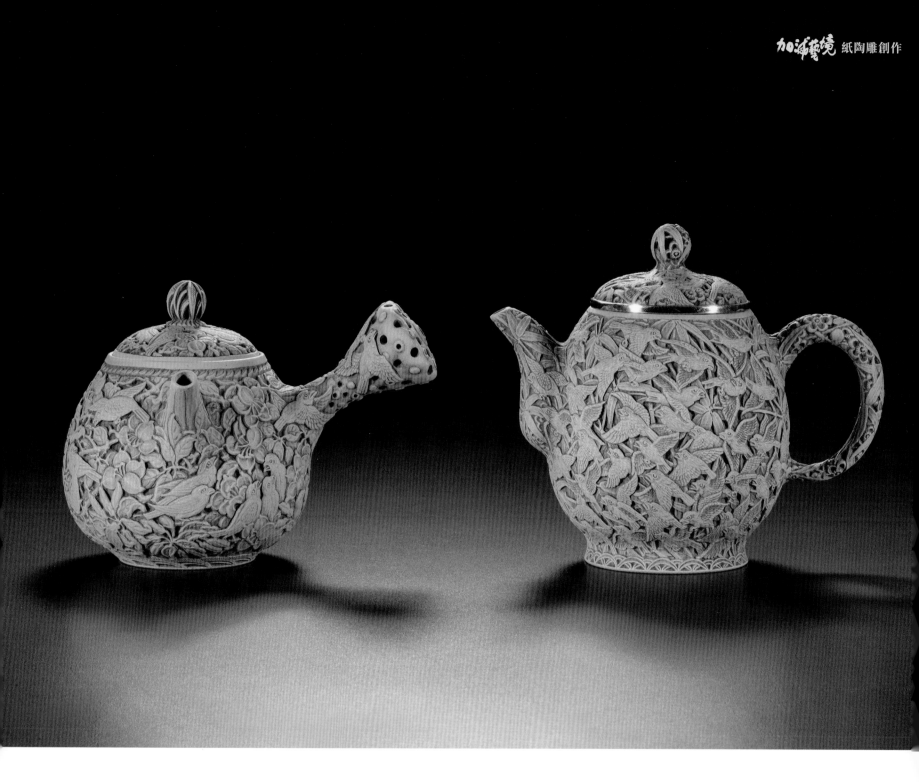

情深花語 Pillow Talk of the Flowers
14.5×11×11cm 2020 黃泥

百鳥獻瑞 The Offering from Birds
15.5×9.5×13cm 2020 黃泥、金

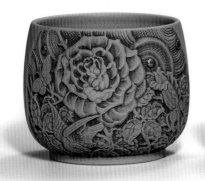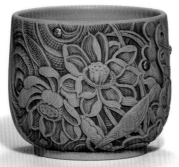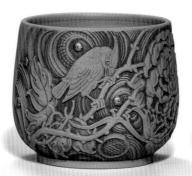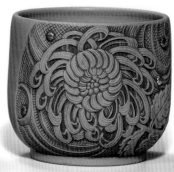

花香鳥語 Springtime for Flowers and Birds

8.5×8.5×7.5cm×4件　2016　黃泥
2017臺灣工藝競賽創新設計組得獎作品

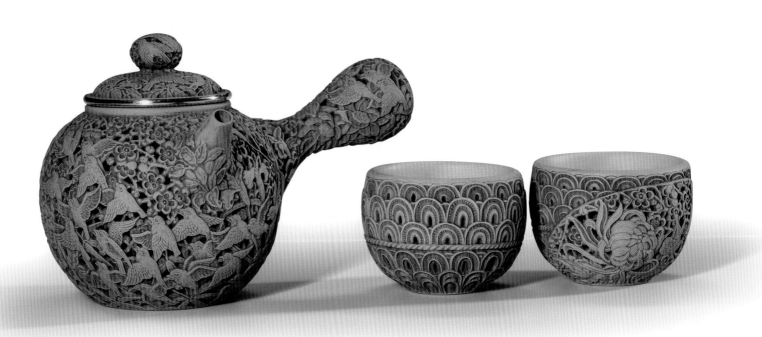

繁花盛開 In Full Blossom

壺 19×13.5×12.5cm　2022
杯 8×8×5.5cm×2件
黃泥、金、雙層鏤雕壺

58隻雀鳥在櫻花、梅花、牡丹花、荷花、玫瑰花、百合
花、鳶尾花、杜鵑花中各自展現最繁華熱鬧姿態，嫻雅
於大地的饗宴中。

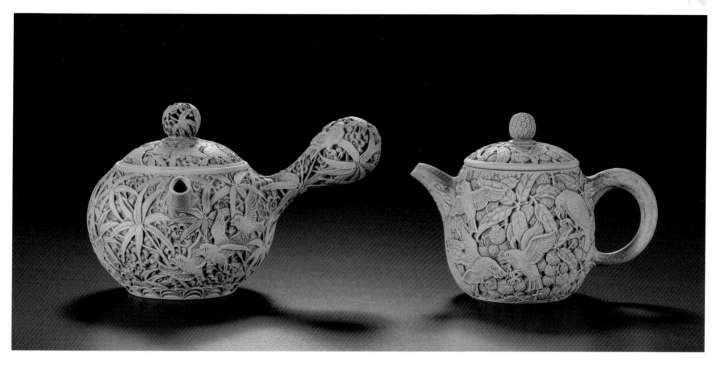

五福長青 Evergreen with All the Luck
15.5×12×10cm 2020 黃泥

大吉大利 Orange for the Best Luck
13×8×9.5cm 2019 黃泥

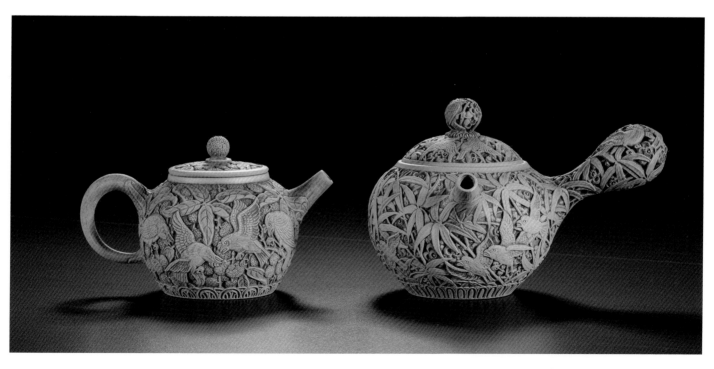

百利大發 With All the Riches
13×9×8.5cm 2021 黃泥

繁花似錦 Blossoming in All Colors
16.5×11.5×10cm 2020 黃泥

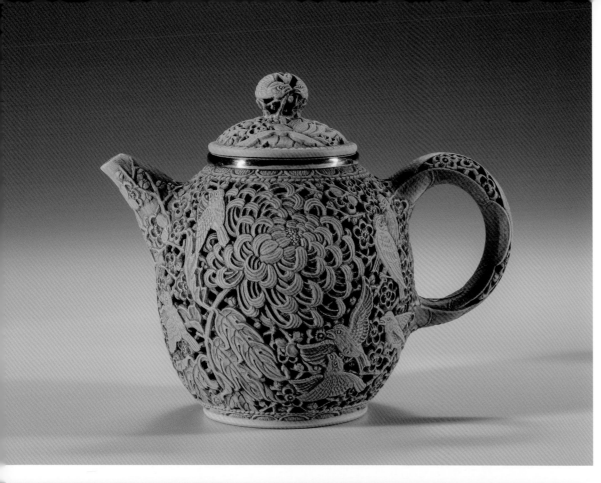

四季花開
Seasonal Flowers

16×9.5×12cm　2022
黃泥、銅、雙層鏤雕壺

春季牡丹象徵「富貴」，夏季荷花象徵「清廉」，秋季菊花象徵「高潔」，冬季梅花象徵「堅貞」，將花木的自然特徵與人的美好品德結合起來，賦予其品格生命。

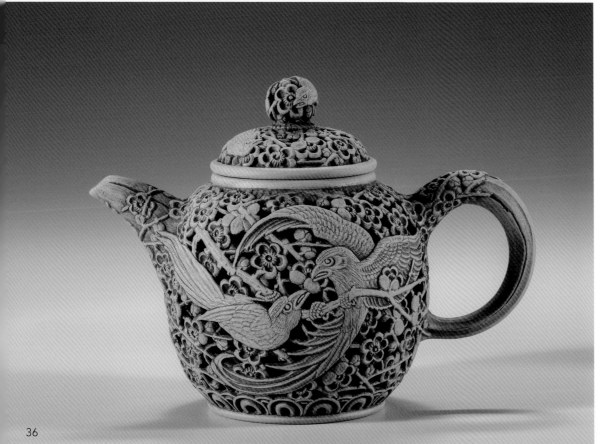

百富188
All the Fortune in Full

15×8.5×11cm　2021
黃泥、雙層鏤雕壺

梅花為冬春交際時盛開，常借喻為君子之德，不畏霜雪。
鵲以報喜預告春光即將回到人間，喜鵲於梅梢上為喜上眉梢之意。
此壺刻以梅花與喜鵲，百富188刻有188朵梅花，寓意有福同享、共同富裕，祝福發大財行大運之意。

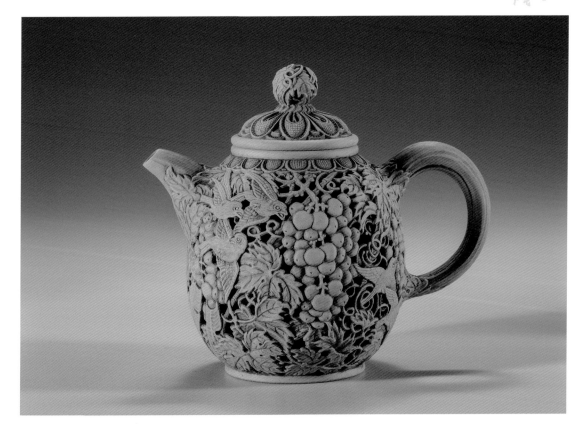

豐收 Harvest

14.5×9.5×12.5cm 2022
黃泥、雙層鏤雕壺

豐收果實纍纍，配上鳥禽互動窺食，寓萬物皆熟，替豐收助陣有著一派富足喜慶之氣氛。

富貴長春
Prosper in Every Spring

15.5×9×11cm 2022
黃泥、雙層鏤雕壺

牡丹花雍容華貴是繁榮富貴的象徵，竹子外堅心虛，高風亮節是文化精神的代表。

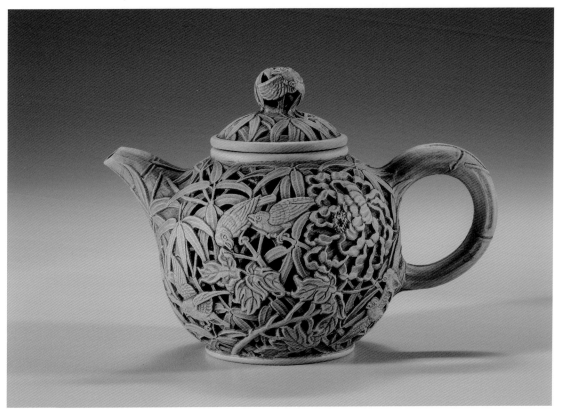

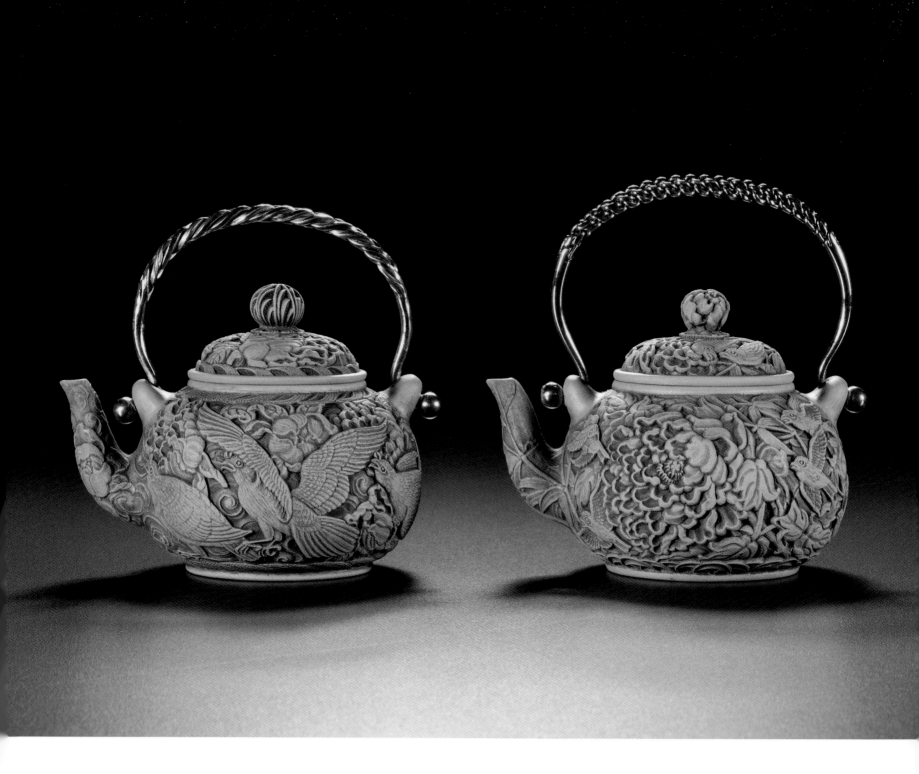

富貴滿園 Prosperity All Around
12×9×11cm 2019 黃泥、銀

國色天香 Stately Beauty and Heavenly Fragrance
12×9×12cm 2020 黃泥、銀

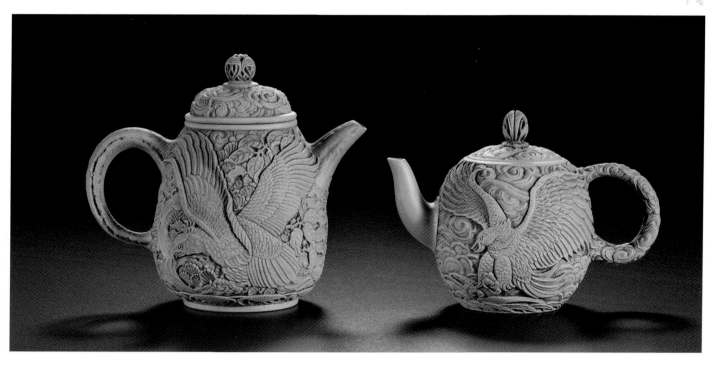

鷹揚萬里 Falcon Crossing a Thousand Miles
13×8×11.5cm 2019 黃泥

鴻圖大展 Rise Like a Falcon
13×7.5×9cm 2017 黃泥

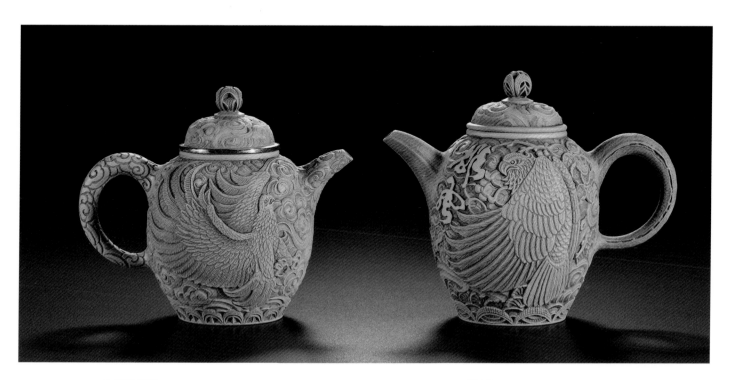

大鵬展翅 Taking Off Like a Falcon
13.5×8×11cm 2019 黃泥

雄風 Majesty
14.5×8×12cm 2019 黃泥

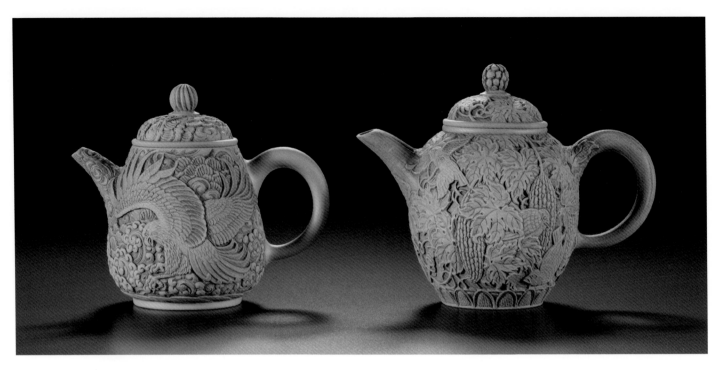

鴻圖大展 Rise Like a Falcon
13×7.5×11cm 2017 黃泥

苦盡甘來 Hard Work Bearing Fruit
15×8×11.5cm 2019 黃泥

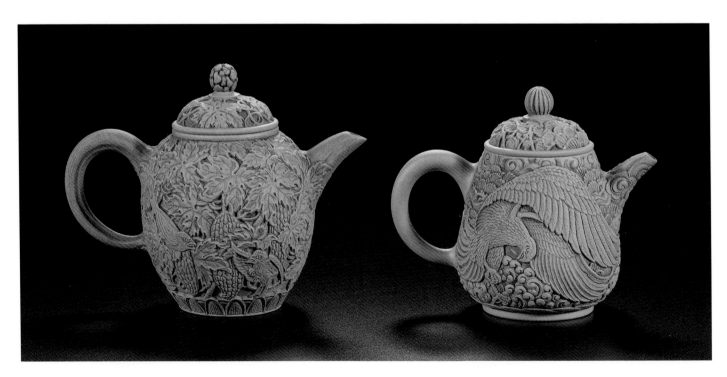

苦盡甘來 Hard Work Bearing Fruit
15×8×12cm 2019 黃泥

鵬程萬里 Falcon Crossing a Thousand Miles
12.5×7.5×10.5cm 2019 黃泥

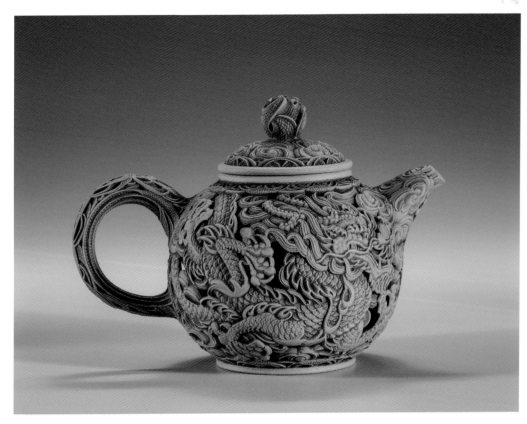

龍飛鳳舞
Dragon and Phoenix

16×10×12cm　2022
黃泥、雙層鏤雕壺

龍：張口旋身力量象徵
鳳：展翅翹尾智慧化身
龍飛鳳舞，周圍祥雲朵朵深情
團聚寓意夫妻和諧喜慶吉祥

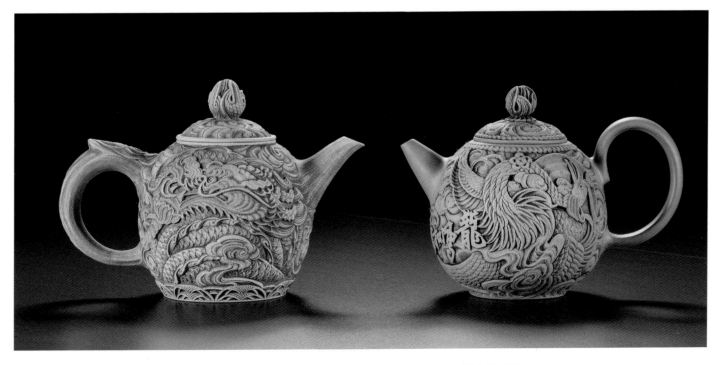

龍鳳呈祥 Dragon and Phoenix with Harmony
15.5×8.5×10.5cm 2015 黃泥

龍鳳呈祥 Dragon and Phoenix with Harmony
14.5×9×10.5cm 2020 紫泥

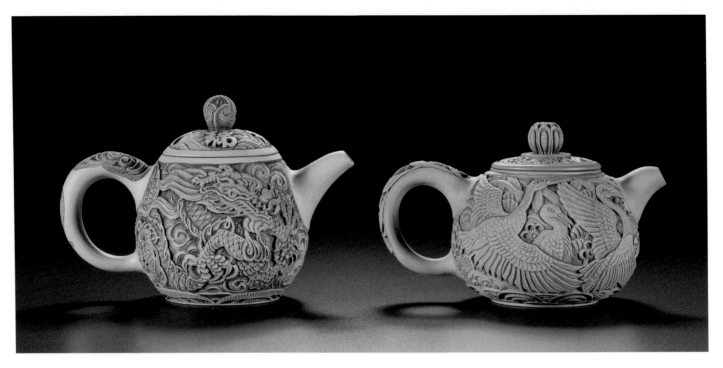

雙龍獻瑞 Double Dragon for Luck
15×9×10.5cm 2015 黃泥

松鶴長齡 Live Long as Cranes and Pine Trees
15.5×9.5×10cm 2015 黃泥、銀

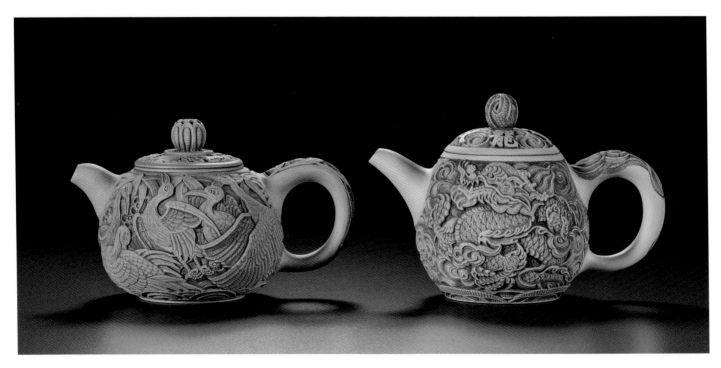

松鶴長齡 Live Long as Cranes and Pine Trees
15.5×9.5×9cm 2015 黃泥

雙龍獻瑞 Double Dragon for Luck
15×9×11cm 2015 黃泥

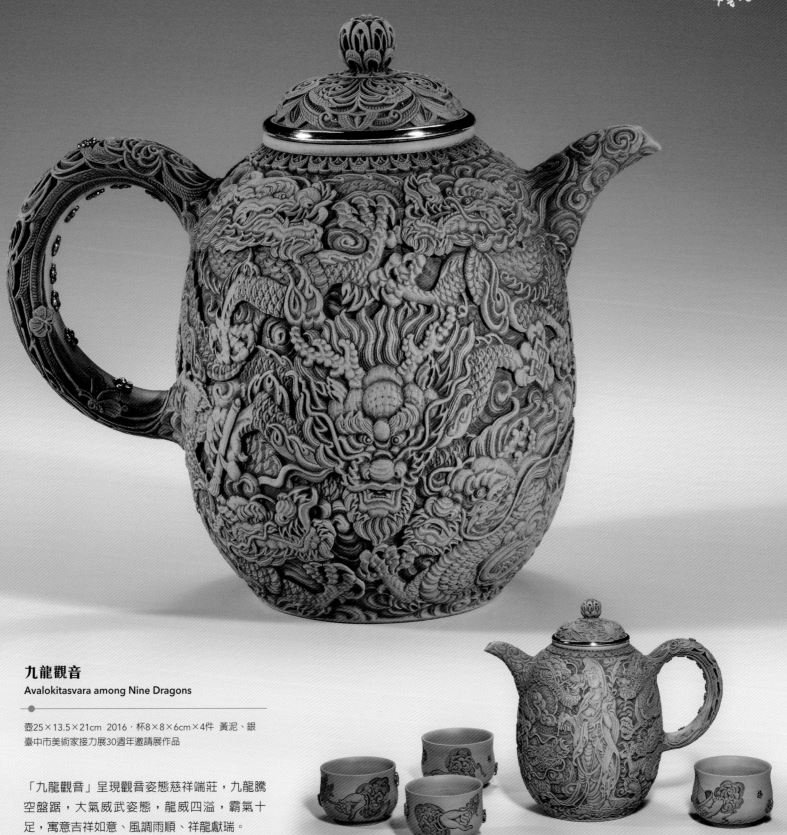

九龍觀音

Avalokitasvara among Nine Dragons

壺25×13.5×21cm 2016・杯8×8×6cm×4件 黃泥、銀
臺中市美術家接力展30週年邀請展作品

「九龍觀音」呈現觀音姿態慈祥端莊，九龍騰
空盤踞，大氣威武姿態，龍威四溢，霸氣十
足，寓意吉祥如意、風調雨順、祥龍獻瑞。

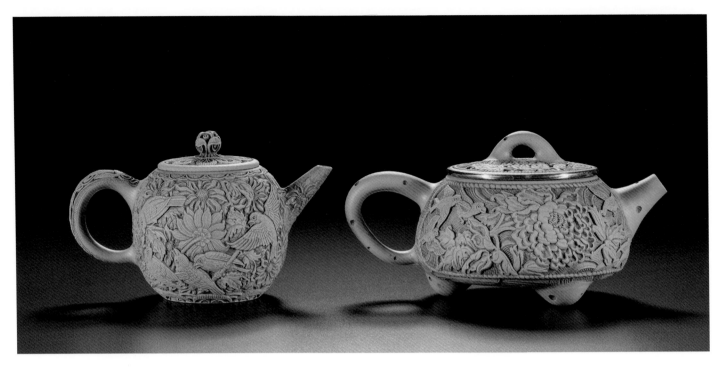

花發鳥鳴 Twittering among Flowers
14×8×8.5cm 黃泥 2019

花開富貴 Blooming with Fortune
16.5×10.5×8cm 2020 黃泥、銅

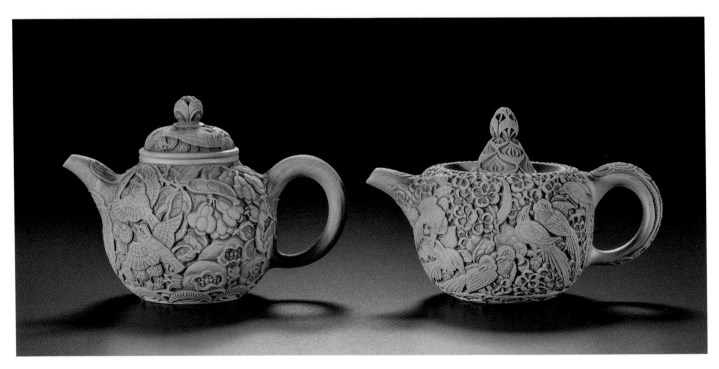

豐碩年年 Fruitful Every Year
13.5×8.5×10cm 2015 黃泥

春暖花開 Spring Blossoms
14×8.5×9cm 2019 黃泥

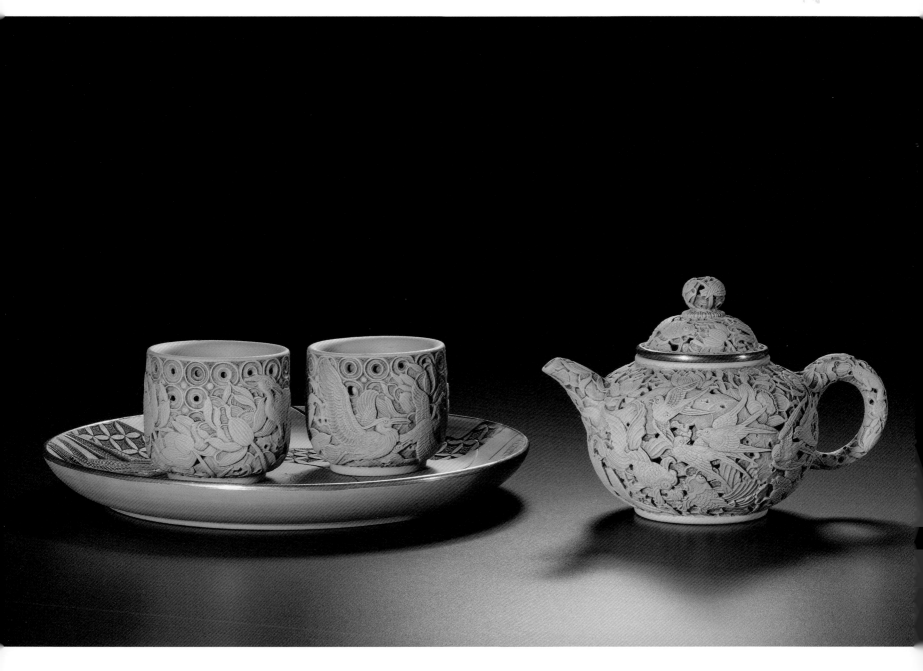

荷豐有餘 (茶具組)
Abundance with Lotus Flowers (Tea Set)

壺 19×12.5×12.5cm 2021 黃泥、銅
杯 8×8×7.5cm×2件
盤 27×27×3.5cm
方圓美術館2023臺灣茶器聯展作品

此組茶器作品以荷花、飛鳥、金魚、青蛙、幾何紋
飾呈現色調古雅、質感細緻、層層有序，豐富完整
的畫面，整體充滿著活力生機。

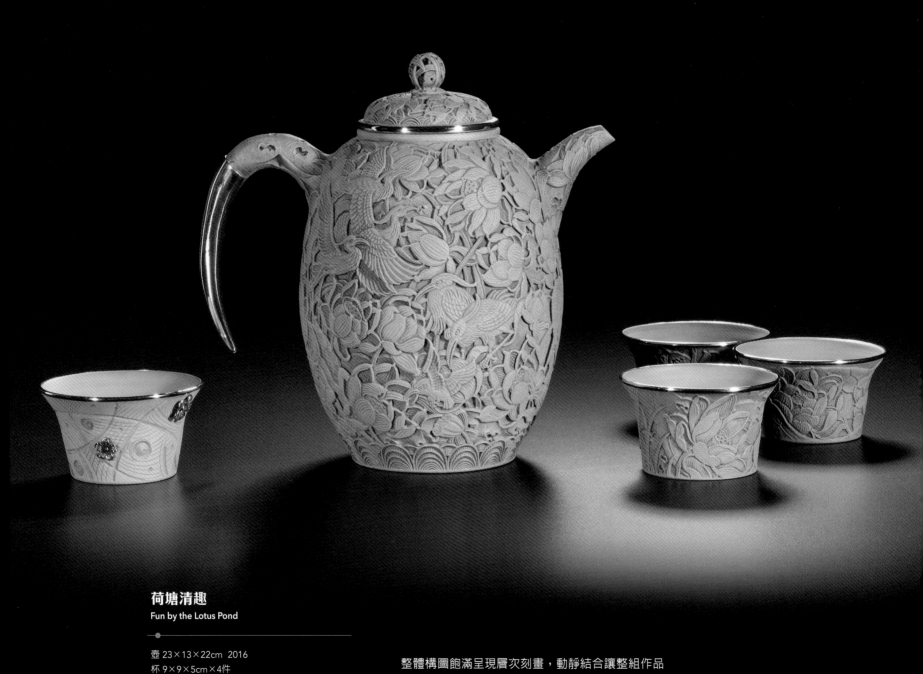

荷塘清趣
Fun by the Lotus Pond

壺 23×13×22cm 2016
杯 9×9×5cm×4件
2016南瀛獎得獎作品

整體構圖飽滿呈現層次刻畫，動靜結合讓整組作品
氣閒神靜，在荷塘之中感到生命的承繼與自然靈
趣。

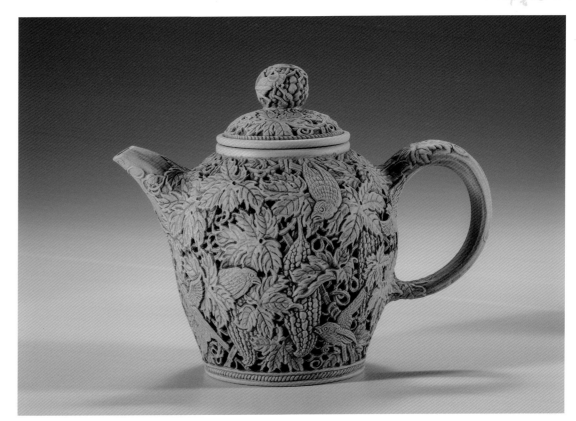

瓜瓞綿綿

Melons on the Vine

16×9×12.5cm　2023　黃泥

延續不斷的瓜藤上結大大小小瓜，引用為祝頌子孫繁盛，傳世久遠。

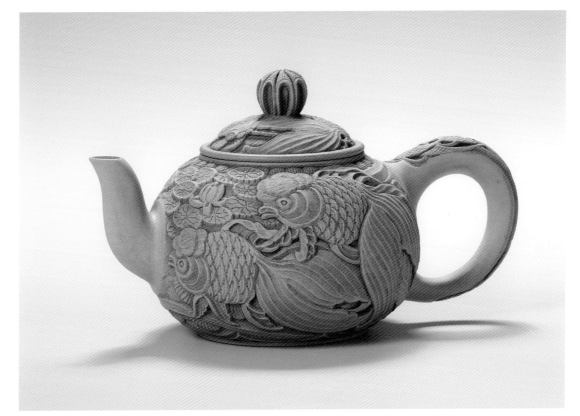

金玉滿堂

Full of Gold and Wealth

15×8.5×8cm　2015　黃泥

自古以來金魚二字與金玉二字諧音，因而有金玉滿堂之意，魚、餘二字同音有餘裕豐足之意。

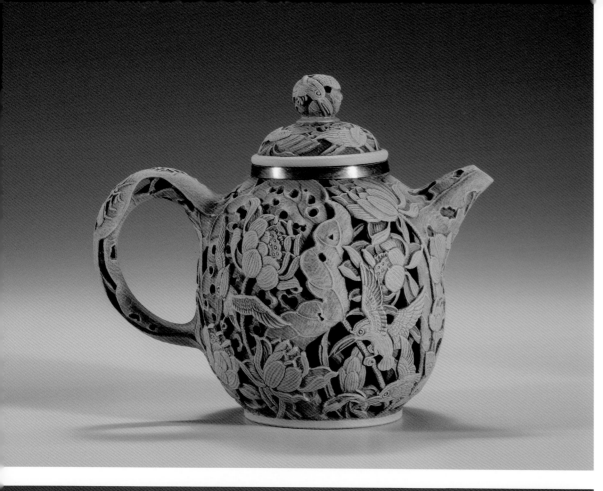

翠羽幽香
Flying Bird over Flowers

———————●———————

15.5×9.5×13cm 2022
黃泥、銅、雙層鏤雕壺

夏日的荷花香氣撲鼻,出污泥而
不染,濯清漣而不妖,有著清白
高潔的象徵。

碩果纍纍
Fruitfulness

———————●———————

14×8.5×12.5cm
黃泥、雙層鏤雕壺

豐收時節果實碩大甜美,碩果纍
纍令人垂涎。

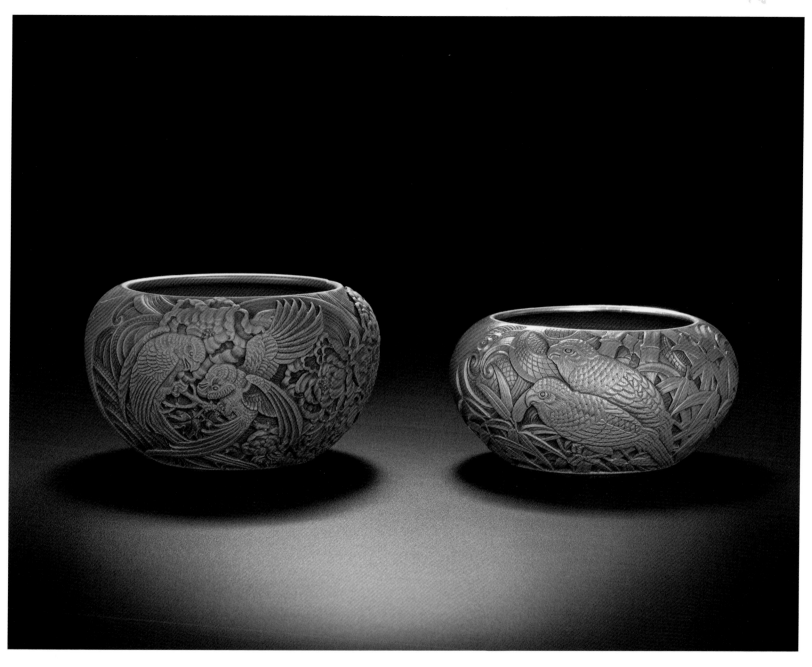

香凝富貴常相依（水方） A Loving Pair with Fortune (Water Vessel)
17×17×10cm 紅泥 2016
2018玉山美術獎得獎作品

儷影依依（水方） A Dependent Pair (Water Vessel)
16.5×16.5×6.5cm 2015 紫砂

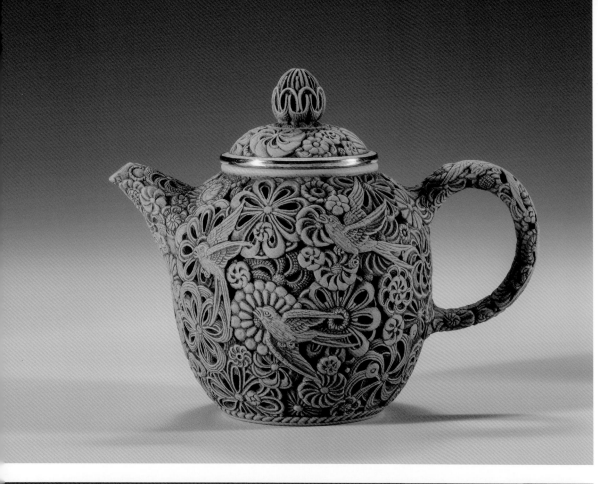

花樣年華
Golden Years

15×9×12cm　2023
黃泥、銅、雙層鏤雕壺

由刻畫錯綜複雜的點、線、面等幾
何造型與傳統花鳥交錯編織出新的
意境，將內部包覆轉換成連續動勢
的構成，形成張力交互牽引，動態
循環，讓人有耳目一新感覺。

展翅高飛
Soaring High

16×9.5×12.5cm　2023
黃泥、銅、雙層鏤雕壺

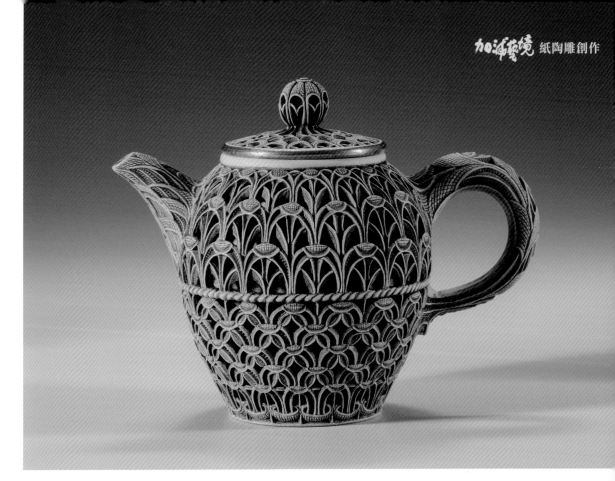

交融
Merging

16.5×9.5×12cm 2021
黃泥、銅、雙層鏤雕壺

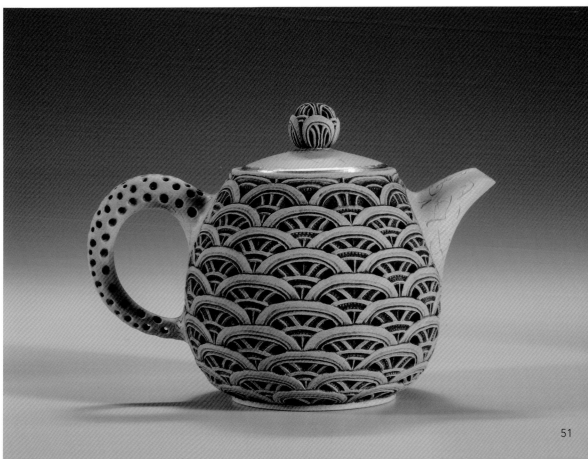

編織夢想
Weaving Dreams

16×10×11.5cm 2022
黃泥、鋁、雙層鏤雕壺

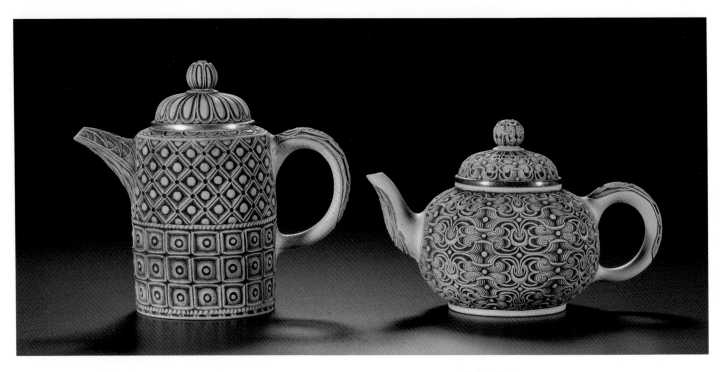

鴻基永固 Solid as a Rock
14×7.5×13cm　2022　黃泥、鋁

永結同心 To Tie the Knot
15.5×9.5×10cm　2022　黃泥、銅

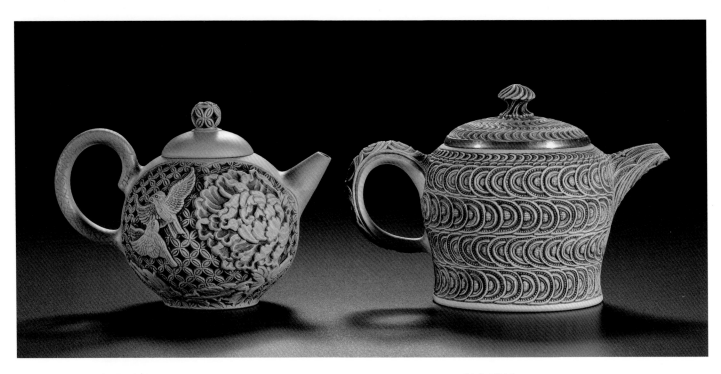

雍容華貴 Elegance and Luxury
12.5×7.5×9cm　2020　紫泥

財源滾滾 Endless Riches
15×8.5×10cm　2022　黃泥、銅

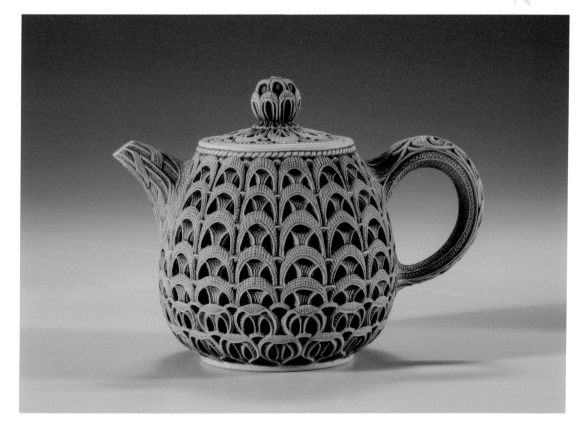

交織複構

Interwoven

15.5×9.5×12cm 2021
黃泥、雙層鏤雕壺

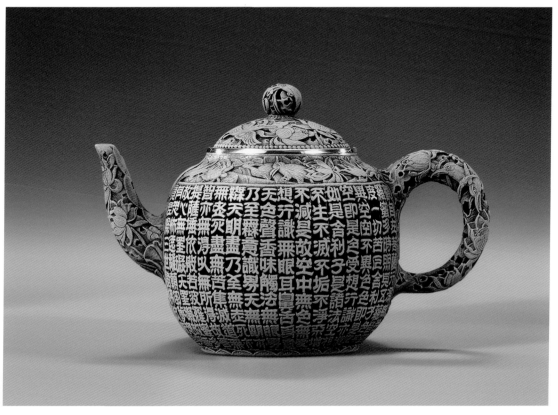

荷塘心經（隸書）

Heart Sutra by the Lotus Pond
(Official Script)

21×12×14cm 2020
黃泥、金

心經全經260字詮釋佛裡最深奧
微妙經典，結合精雕、製壺、金
工、書法4位作者，呈現出整體
畫面整潔，字字珠秀、筆筆工
整，一絲不苟，可以靜心亦可療
不足憂。

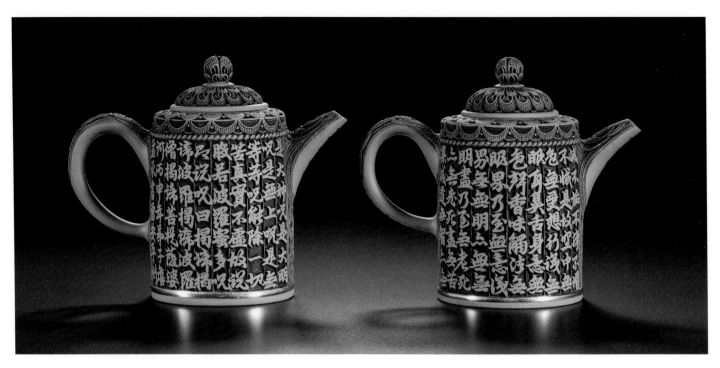

心經（行書）對壺 Heart Sutra (Semi-Cursive Script) Pot Pair
14.5×7.5×12.5cm · 14×7.5×12cm 2017 黃泥、鋁

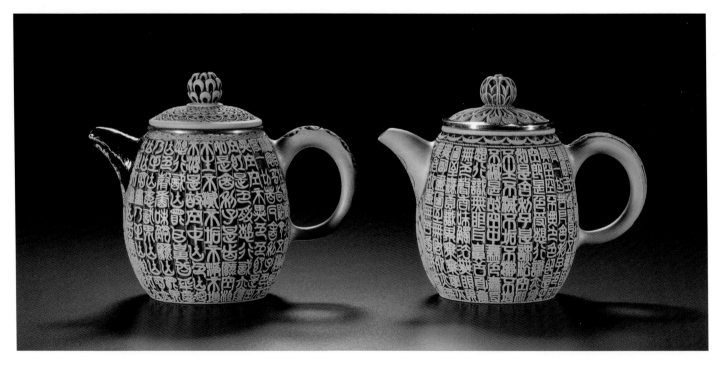

心經（篆書） Heart Sutra (Seal Script)
14×9×12cm 2020 黃泥、銀

心經（中山篆書） Heart Sutra (Zhongshan Seal Script)
14.5×8.5×12cm 2020 黃泥、銅、生漆

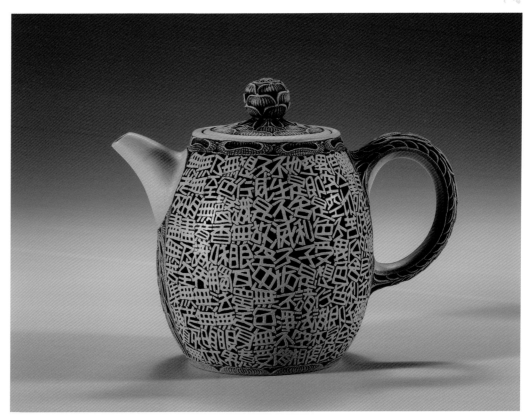

心經 (pop)
Heart Sutra (Pop)

———●———

15.5×9×12cm 2022
黃泥、雙層鏤雕壺

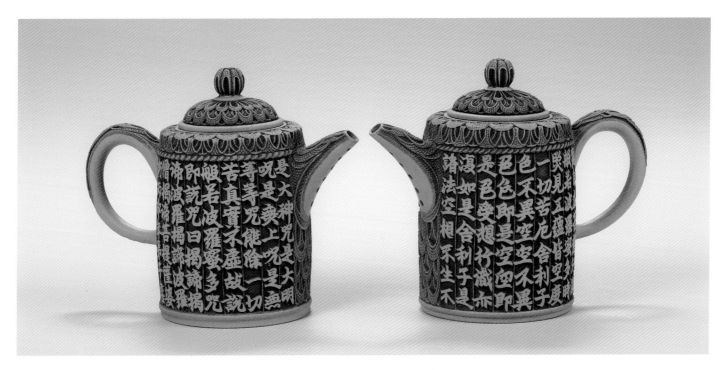

心經（行書）對壺 Heart Sutra (Standard Script) Pot Pair

14×7×11.5cm · 14×7×11cm 2017 黃泥

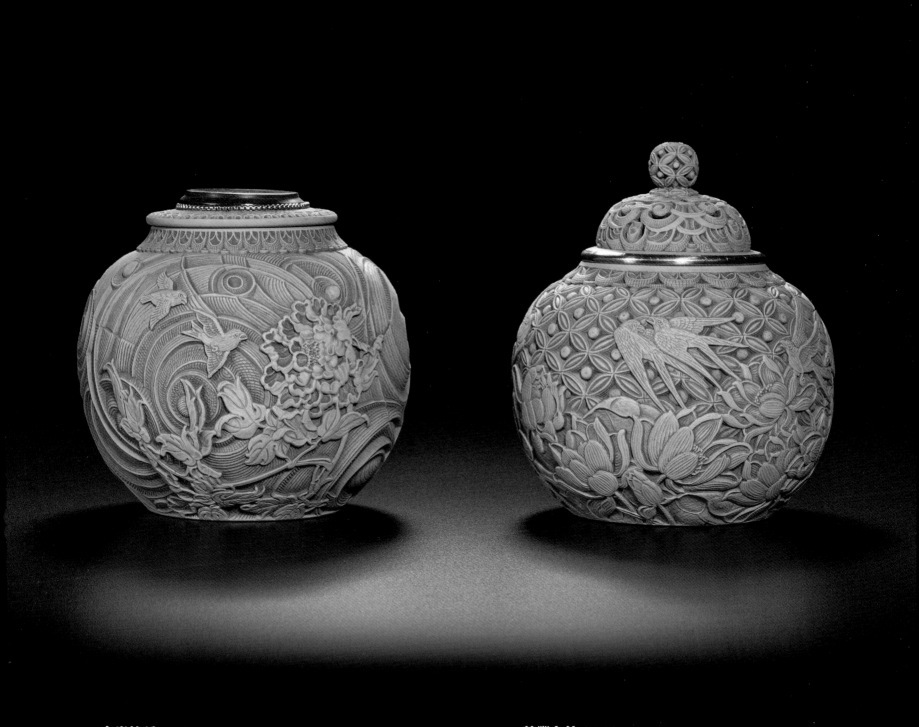

富貴綿延（茶倉） Endless Prosperity (Tea Container)
15×15×14.5cm 2022 黃泥、花梨木、不銹鋼

荷豐有餘（茶倉） Surplus Prosperity with Lotus Flowers (Tea Container)
14.5×14.5×17cm 2022 黃泥、銅

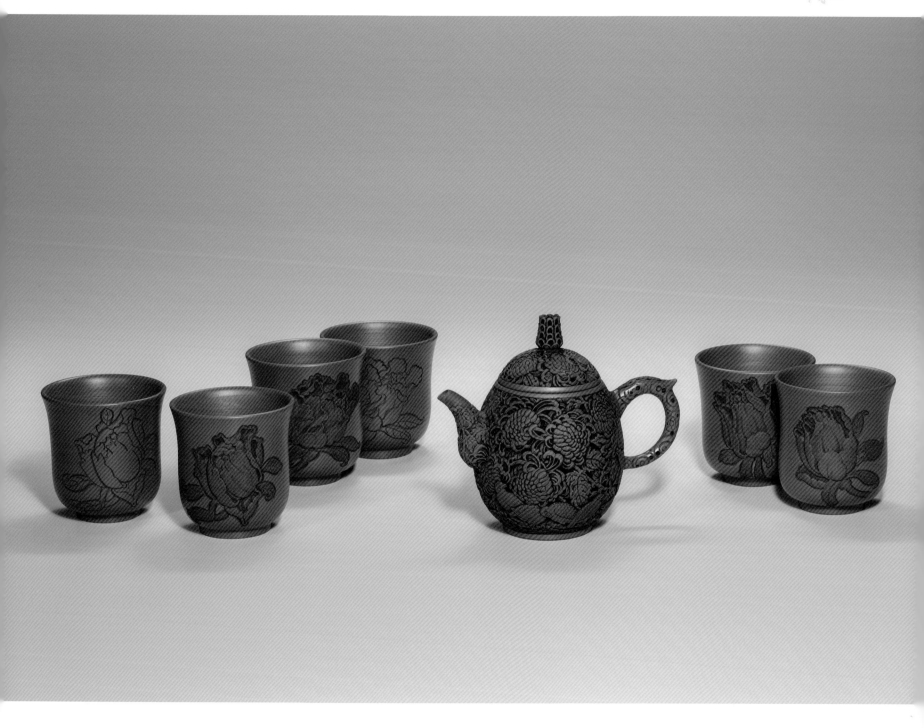

牡丹（對杯） Peony (Cup Pair)
6.5×6.5×7cm 2017 紅泥

安居樂業 Live in Peace and Work with Joy
壺 13×8×13cm 2019 紅泥

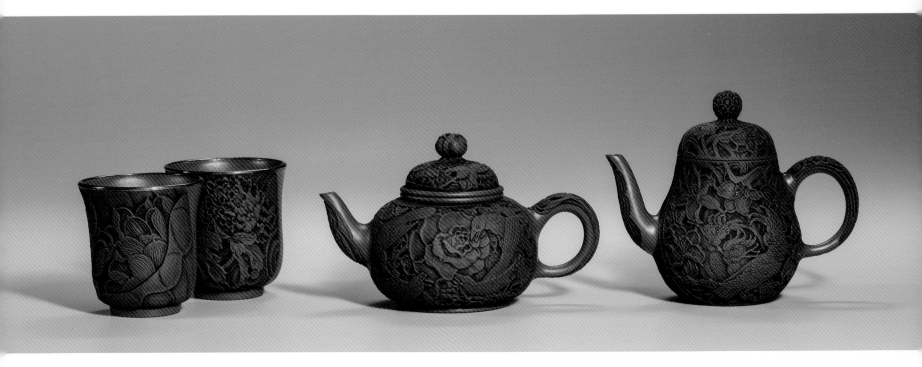

花語（對杯） The Talk of Flowers (Cup Pair)
6.5×6.5×7cm 2018 紅泥、銅

玫瑰花語 The Talk of Roses
14.5×9×9cm 2016 紅泥
2018玉山美術獎得獎作品

和合 Harmony
13×7.5×10.5cm 2018 紅泥

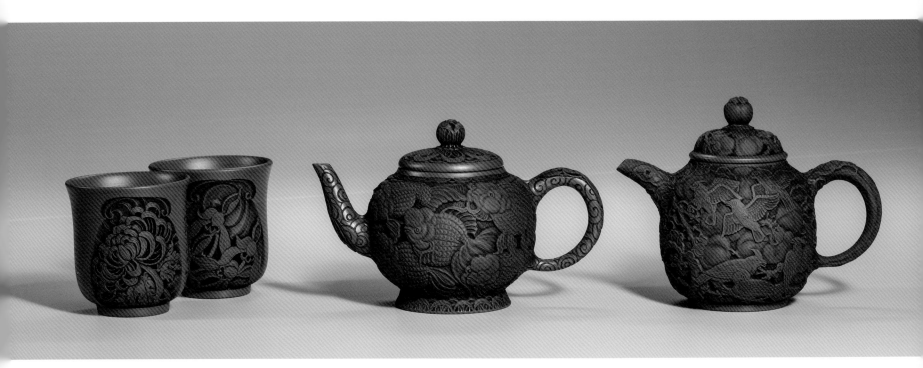

梅蘭竹菊（對杯） Plum Blossoms, Orchid, Bamboo,
and Chrysanthemum (Cup Pair)
6.5×6.5×7cm 2018 紅泥

十全十美 Perfection in All Aspects
14.5×8.5×9.5cm 2018 紅泥

萬事如意 All the Best with Everything
13×8×10.5cm 2018 紅泥

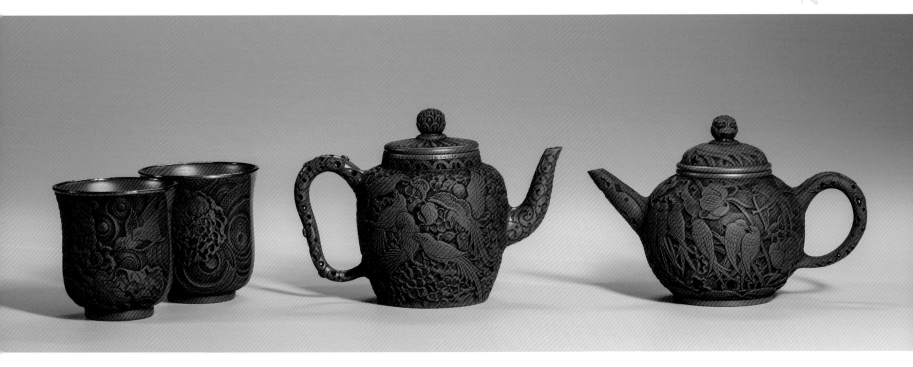

花語（對杯） The Talk of Flowers (Cup Pair)
6.5×6.5×7cm 2018 紅泥、銅

戲春 Playing in Springtime
14×8×10cm 2018 紅泥

夏趣 Fun in Summertime
14.5×8.5×9.5cm 2018 紅泥

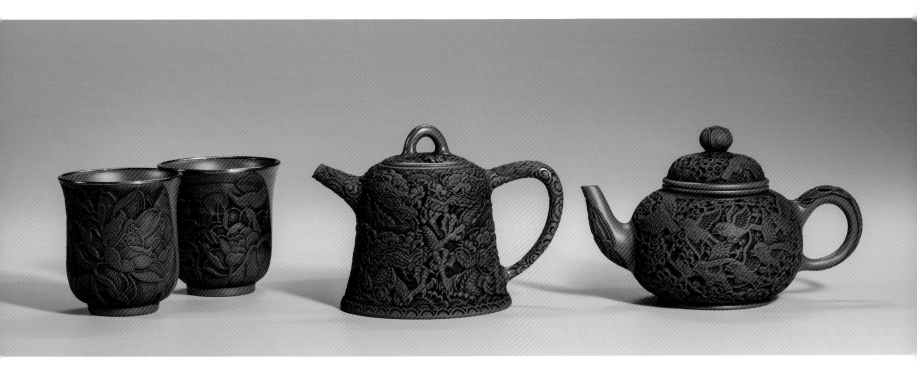

花語（對杯） The Talk of Flowers (Cup Pair)
6.5×6.5×7cm 2018 紅泥

九龍 Nine Dragons
13×9×9.5cm 2019 紅泥

百梅迎春 Plum Blossoms for Spring
15×9×9cm 2016 紅泥
2018玉山美術獎得獎作品

花開四季 (茶具組)
Four seasons of Flowers (Tea Set)

黃泥、銀、銅、不銹鋼
總尺寸 90×60×15cm 2022

茶壺 14×9×11cm
茶海 8×8×8.5cm
茶筒 8×8×11cm
茶匙 11×6.5×3.5cm
茶倉 16×16×13cm
茶盤 23×23×8cm

水方 17×17×12cm
蓋置 8×8×4cm
茶杯 5.5×5.5×5cm×8件
香爐 9×9×11cm
點心盤 16×16×5cm (大)、12×12×5cm (小)

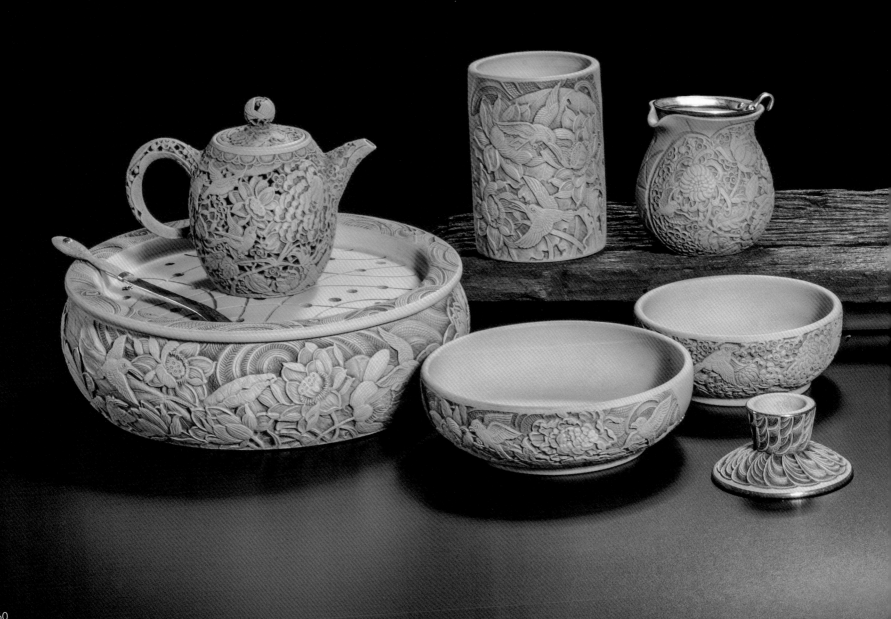

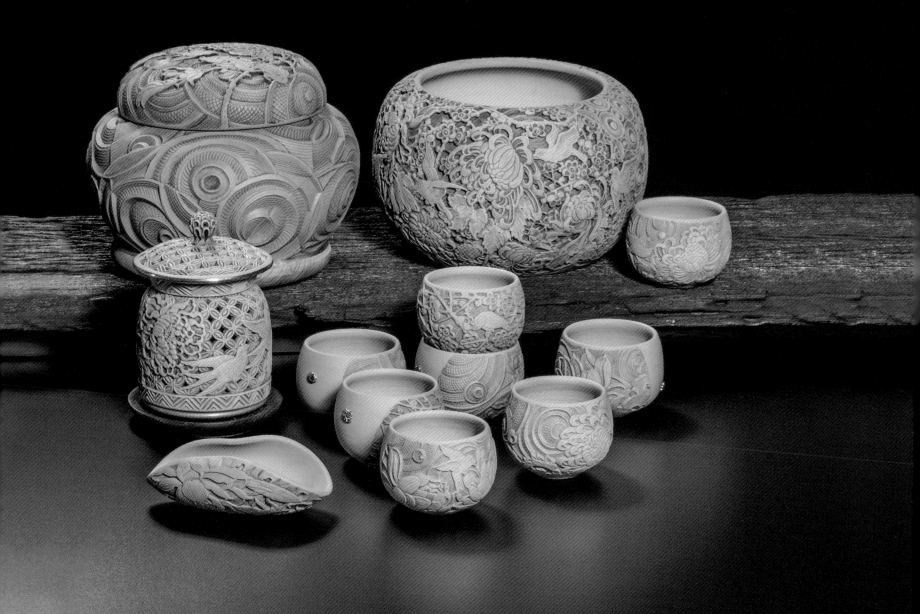

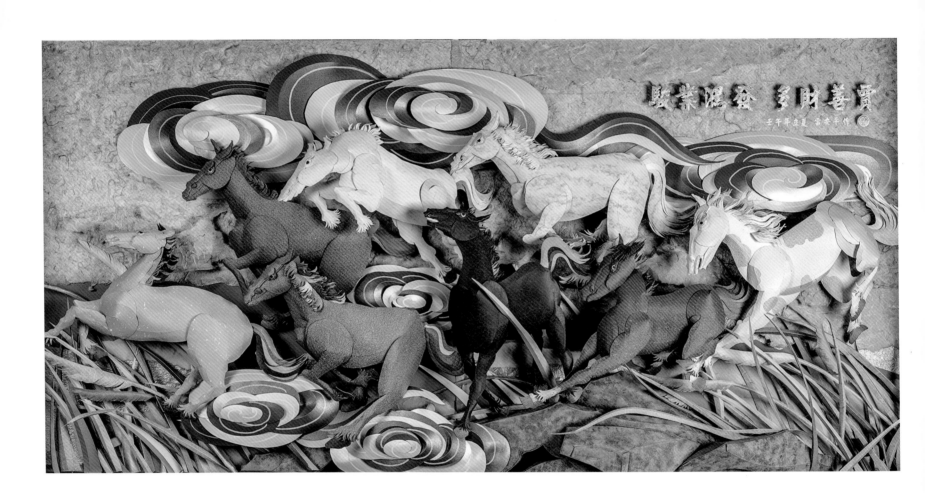

八駿圖

Eight Horses

175×108.5×20cm　2018　美術紙

駿馬騰躍，身姿矯健腳踏祥雲，寓意事業功名、
學業、財運飛黃騰達，扶搖直上。

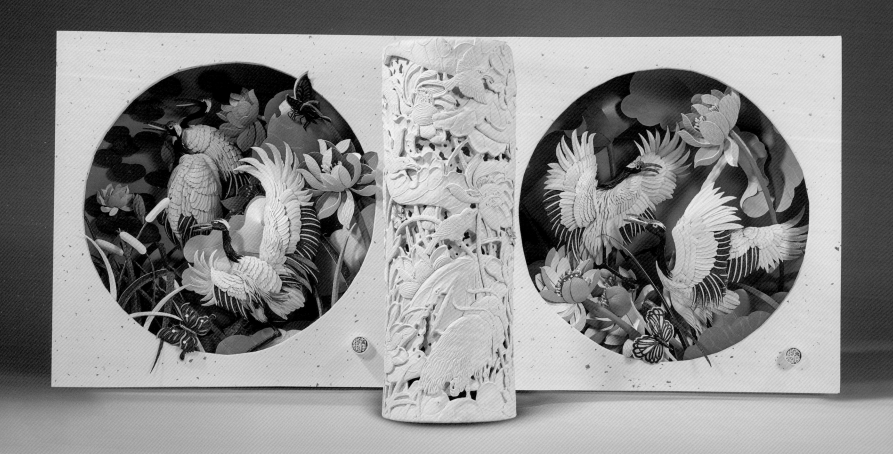

荷韻滿塘 Lotus Flowers by the Pond

140×43×54cm　2017　美術紙、白瓷、銀、油彩
2018臺南美展得獎作品

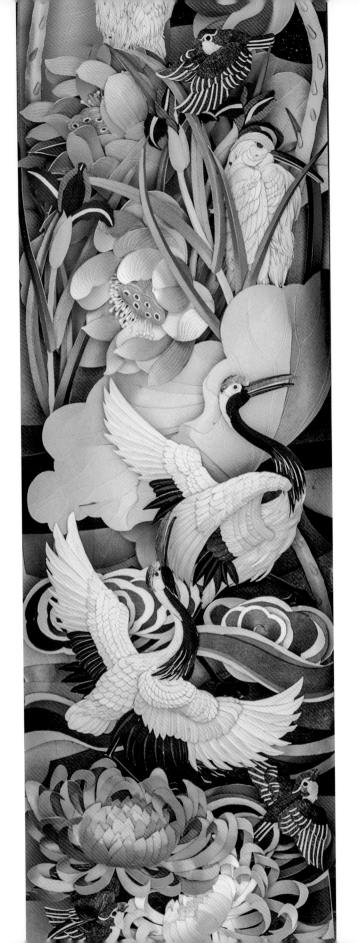

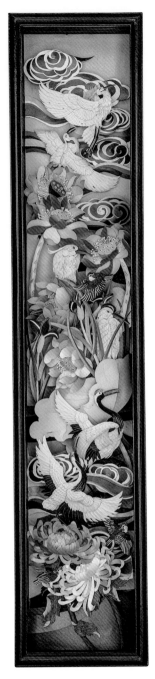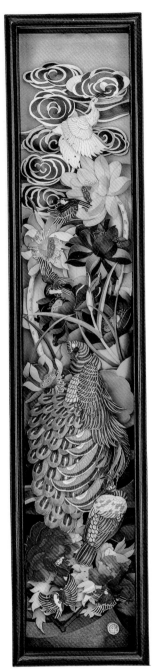

花開吉臨 Blossoming with Fortune

117×50×12cm 2018 美術紙 2018臺灣工藝競賽得獎作品

此作品以花卉為底，結合大大小小禽鳥，以紙張的肌理、色彩，營造出立體層次感，構圖採多樣繁複編排，呈現百花齊放萬象更新的景象，表達著人們對太平盛世安康生活的期盼。

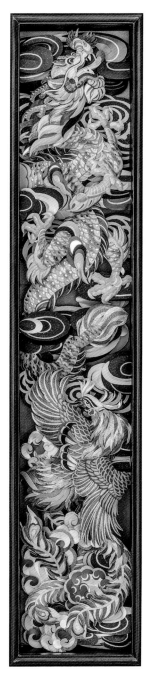

龍飛鳳舞 Dragon and Phoenix

125×68×14cm 2023 美術紙

龍在飛騰、鳳在歡舞，形容氣勢奔放自在，有婚姻美滿，事業飛黃騰達美意。

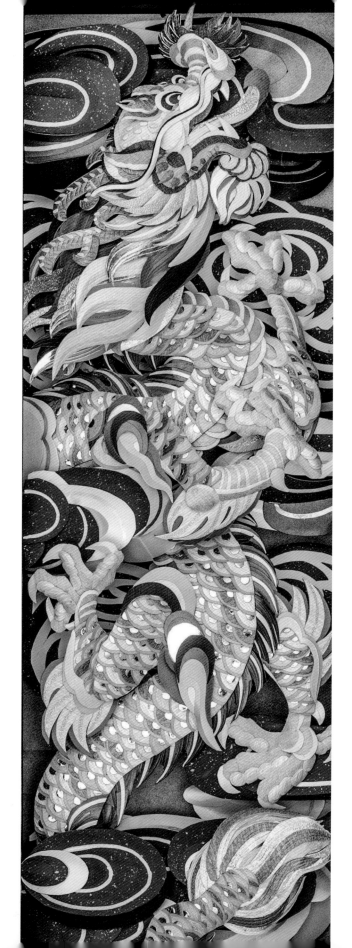

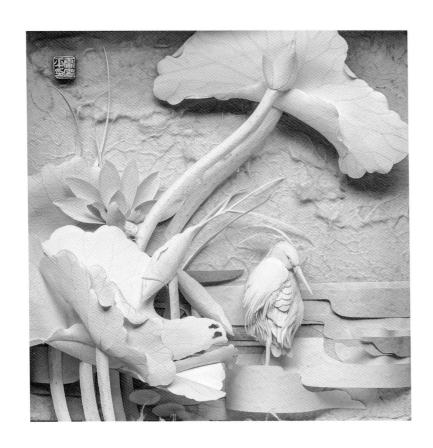
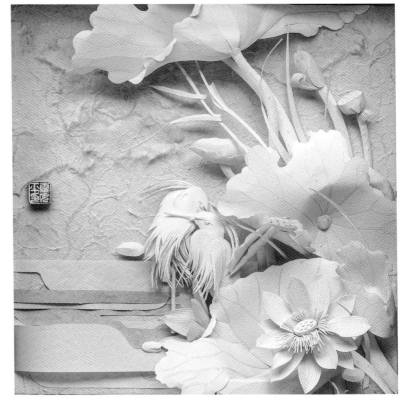

香遠溢清 Fragrance that Travels Afar

80×41×13cm　2005　美術紙
2006臺灣工藝競賽得獎作品

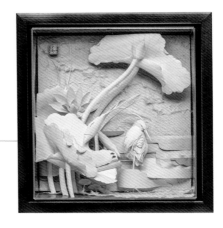
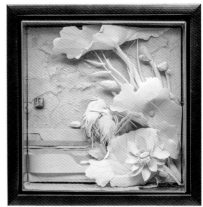

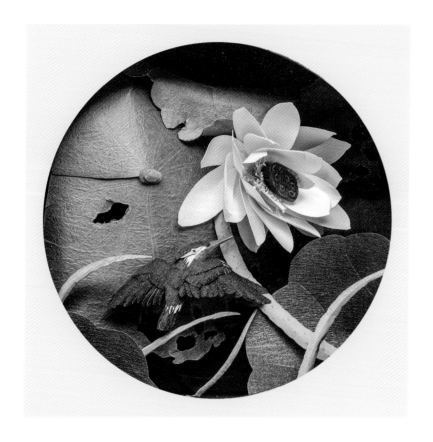

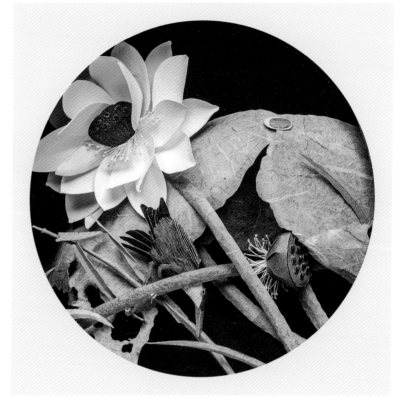

初綻 First Bloom

93×47×18cm 2023 美術紙

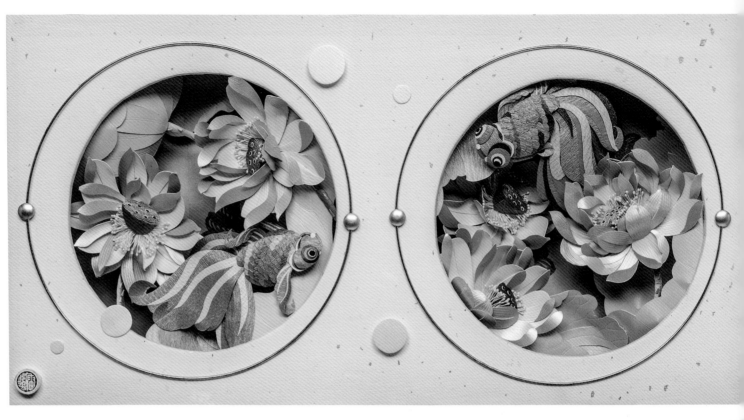

百花爭豔 In Full Bloom

101×41×9cm 2020 美術紙
2021臺灣工藝競賽得獎作品

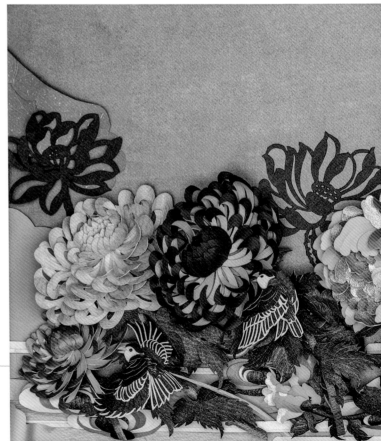

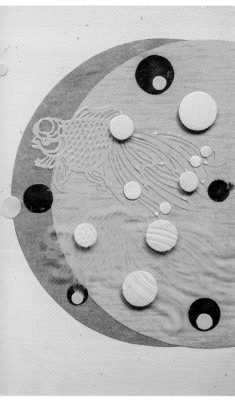

有餘 Surplus

95×41×9.5cm 2022 美術紙

用金銀兩色系，呈現清新高雅亮點，荷花出淤
泥而不染比喻人品高潔，有和氣生財之意，悠
遊的金魚有金玉滿堂之意，代表著富貴有餘。

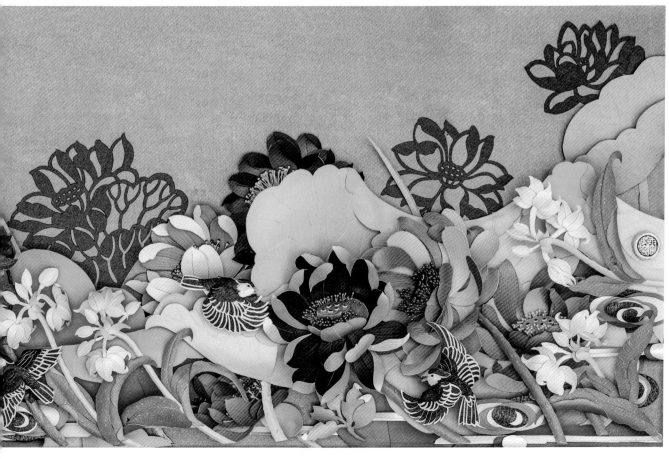

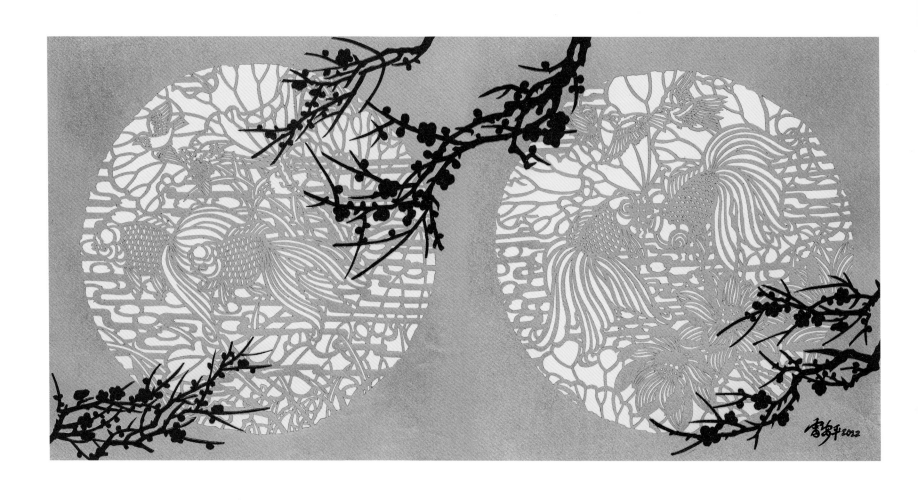

荷花金魚 Goldfish in the Lotus Pond

78×39×2cm 2022 美術紙

此作品為金魚、荷花、梅花，一動一靜畫面做陰陽、塊線、色彩、疏密、組畫形式構成，融於紙上鏤空，剪刻於作品中。

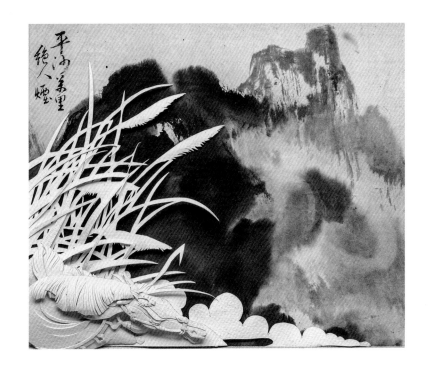

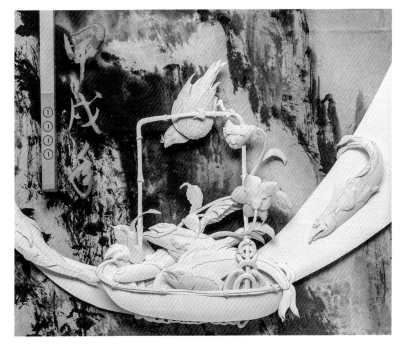

中國風 A la Chinese

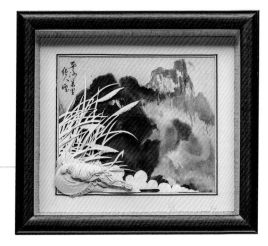

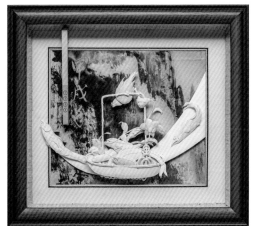

43×38×6cm　1995　美術紙
1995全省美展得獎作品

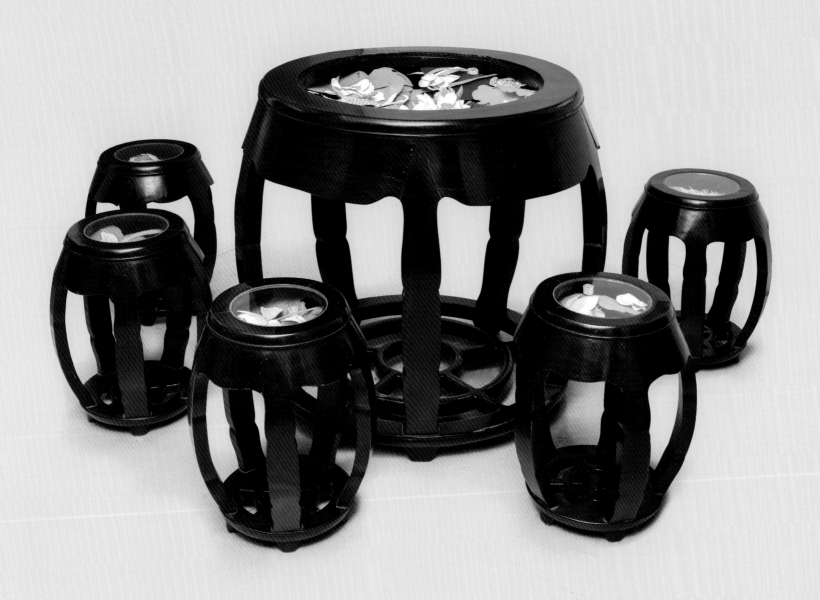

仲夏時節 (家具全組)
Midsummer (Full Furniture Set)

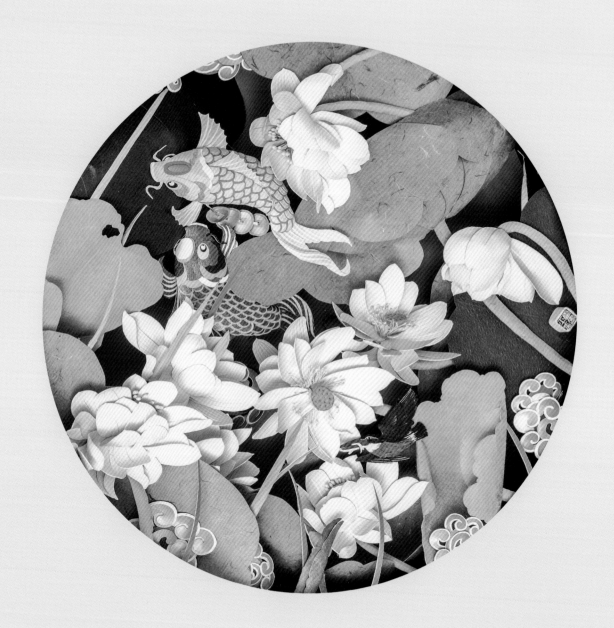

仲夏時節（傢俱組）
Midsummer (Furniture Set)

桌 88×88×81cm 2001
椅 33×33×49cm×5件
美術紙

這組作品是一組一桌五椅，古典優美的鼓造型傢俱與紙浮雕結合，呈現出作品的藝術生活化。

作品畫面描繪仲夏時節荷花盛開與碧綠滾圓荷葉，在陣陣輕風中翩翩起舞，雙鯉魚悠遊穿梭、怡然快活，展現出大自然生機盎然生生不息的活力。

雷安平 年歷記事

獲獎

2021 榮獲礡溪美展立體工藝類優選 並獲【全興獎】「吉瑞」
臺灣工藝競賽 入選「百花爭豔」

2020 榮獲南投縣玉山美術獎工藝類【首獎】「刻意情懷」

2019 榮獲臺南美展傳統工藝類第一名並獲選【臺南獎】「富貴延綿」
南投縣玉山美術獎工藝類佳作「春花秋實」
榮獲臺灣工藝競賽美術工藝類佳作「百鳥臻祥」

2018 臺灣工藝競賽美術工藝類入選「花開吉臨」
南投縣玉山美術獎工藝類佳作「花鳥寄情」
榮獲臺南美展傳統工藝類 第二名「荷韻滿塘」
臺灣工藝競賽美術工藝類「百鳥獻瑞」創新設計類「花香鳥語」雙入選
榮獲臺南美展傳統工藝類第二名「福到人間」

2016 榮獲【南瀛獎】工藝類 優選「荷塘清趣」

2015 臺灣工藝競賽傳統工藝類入選「五福臨門」

2013 獲選臺中市文化局第八屆雕塑類【大墩工藝師】殊榮
榮獲臺灣工藝競賽傳統工藝類佳作「君子壺」

2012 第四屆金壺獎創作 入選「四季風華」

2010 臺灣工藝競賽傳統工藝組 入選「春、夏、秋、冬」
第三屆金壺獎創作類入選「風華」

2009 榮獲第五屆臺灣陶瓷金質獎創意獎類優選「荷香」
榮獲第二屆金壺獎佳作「春韻」

2008 臺灣工藝競賽傳統工藝組「豐碩年年‧茶具組」創新設計組 「阿福四用杯組」雙入選
第一屆金壺獎創作入選「圖騰、如意」

2006 工藝之夢—臺灣工藝新秀獎「香遠溢清」
國家工藝獎入選「四季風華」
大墩美展工藝類 入選「春鳴」
全省美展工藝類入選「金剛力士」

2004 大墩美展工藝類入選「群芳獻瑞」

2001 獲國家文藝基金會獎勵補助

1996 大墩美展工藝類入選「雪齋」

1995 全省美展工藝類優選「中國風」

1994 獲國軍文藝金像獎漫畫類優選「我們同在一條船上」
國軍文藝金荷獎漫畫類第 一名「我們同在一條船上」

1992 全省美展工藝類入選「童話人生」

1991 榮譽觀護人協進會反毒漫畫類第一名並獲特優
行政院環保署全國海報設計佳作
中部美展攝影類入選「廟會」

個展

2023 臺中市文化局大墩文化中心「加減藝境 雷安平紙陶雕創作」邀請個展

2014 獲藝術薪火相傳－第4屆臺中市美術家接力展【刻意情懷】雷安平陶雕創作個展

2008 瓷瑤陶藝－臺北大葉高島屋百貨，太平洋 SOGO 百貨個展－「美意延年」雷安平陶雕創作個展

2006 臺中市文化局大墩文化中心個展

2005 新竹市文化局個展
南投縣文化局個展

2004 彰化縣文化局個展

2003 苗栗縣文化局個展

2001 臺中市文化局大墩文化中心個展

1991 卡迷紙藝世界個展

聯展

2003-2023 臺中市當代藝術家邀請展

2023 方圓美術館臺灣茶器聯展

2022 「總統府工藝邀請展」與自然做朋友特展

2020 方圓美術館 臺灣茶器聯展

2019 臺南文化局「臺南獎」得獎作品聯展

2018 薪傳30 臺中市美術家接力聯展